ICONS

THE Garden AT Eichstätt

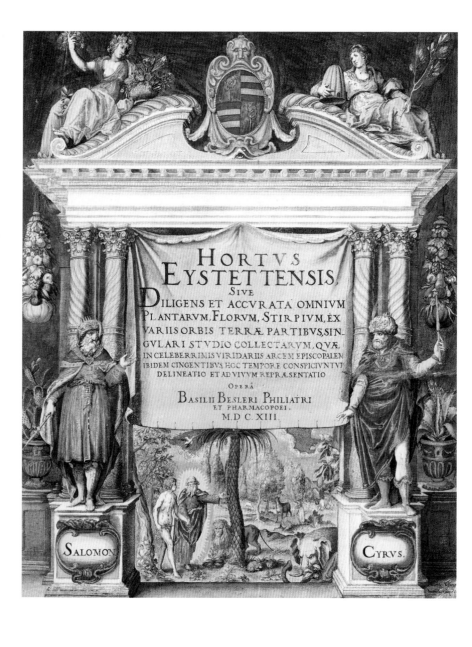

HORTVS
EYSTETTENSIS,
SIVE
DILIGENS ET ACCVRATA OMNIVM
PLANTARVM, FLORVM, STIRPIVM, EX
VARIIS ORBIS TERRÆ PARTIBVS, SIN-
GVLARI STVDIO COLLECTARVM, QVÆ
IN CELEBERRIMIS VIRIDARIIS ARCEM EPISCOPALEM
IBIDEM CINGENTIBVS HOC TEMPORE CONSPICIVNTVR
DELINEATIO ET AD VIVVM REPRÆSENTATIO
OPERÂ
BASILII BESLERI PHILIATRI
ET PHARMACOPOEI.
M. D. C. XIII.

SALOMON

CYRVS.

THE Garden AT Eichstätt

BASILIUS BESLER'S
BOOK OF PLANTS

A SELECTION
OF THE BEST PLATES

TASCHEN

KÖLN LONDON MADRID NEW YORK PARIS TOKYO

In Icona affabrè effictam clariff. Pharmacopœi

NORIMB. DN. BASILI BESLERI.

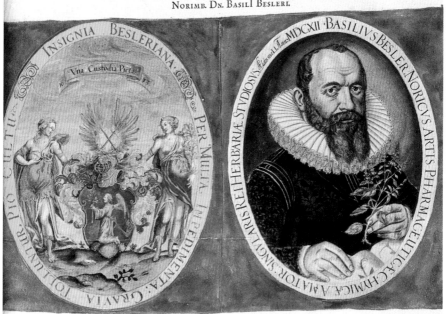

ESLERUM glyptes BASILEION imagine pulcrâ,
 Quisquis es, ó Hospes, reddidit, ecce, tibi.
Nempe viri vultus dedit heic, atq; ora tueri:
 Cernere vis mentis dona sagacis? age,
HERBARUM magnum hoc PLANTARUMq; Amphitheatron.
 Inspice, quas dotes AREATINUS habet.
Divitiasq; HORTUS: Paradeison dixeris ipsum:
 Condidit immortale hoc BASILEIUS Opus.

GEORG. REMUS, P. A JCtus

CONTENTS

Spring

Winter Summer

Autumn

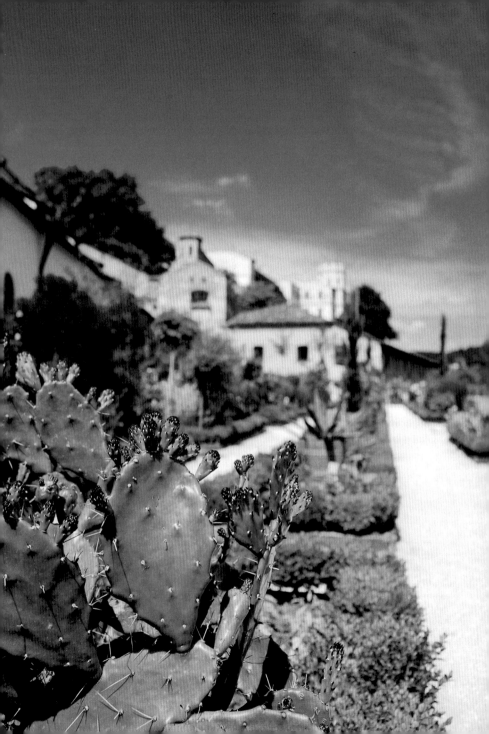

PAEONIA OFFICINALIS
Common peony

LATHYRUS LATIFOLIUS
Perennial pea

CANNA INDICA
Red indian shot

OPUNTIA FICUS-INDICA
Indian fig

CNICUS BENEDICTUS
Blessed thistle

ECHINOPS
Globe thistle

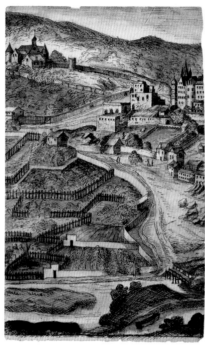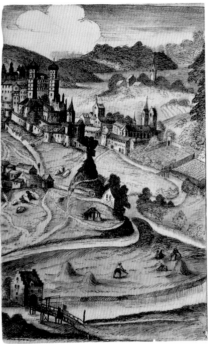

Ill. 1
Philipp Hainhofer
The Willibaldsburg, view from the north, c. 1611
Watercolor over pen
Wolfenbüttel, Herzog-August-Bibliothek, Cod. Guelf. 23.3.Aug. 2°, fol. 13v – 14r.

THE Garden at Eichstätt

THE HISTORY OF THE GARDEN AND THE BOOK

I. THE WILLIBALDSBURG CASTLE AND ITS GARDEN

Approaching Eichstätt by the main road from the north, you are greeted by a fascinating view across the Altmühl valley. On the other side, at the same level on the Frauenberg hill towering high above the Altmühl, rises the Gemmingen building of the Willibaldsburg castle, still an imposing edifice despite the ravages of the 19th century. In the valley to the east lies the old cathedral city, while to the west is the former Augustinian canonical order of Rebdorf.

The Willibaldsburg castle was founded in the middle of the 14th century as the residence of the prince bishops of the Eichstätt bishopric. In later years it was repeatedly extended and fortified, with major works being carried out for 200 years after it was founded, involving the alteration of old buildings and construction of new ones. These works continued into the first 30 years of the 17th century. Like many other places in Germany, the residence in Eichstätt was made into a stately but well-fortified castle. From 1569, Prince Bishop Martin von Schaumberg (1560–1590) completely changed the front of the eastern side of the castle on the Frauenberg and built up an extensive, three-winged structure from the old curtain wall that was closed to the outside world. This was a prestigious residential building, although the basements did continue to house weaponry (ill. 2).

After the short rule of Kaspar von Seckendorff (1590–1595), Prince Bishop Johann Konrad von Gemmingen (1593/95–1612) devoted his energies to renovating the old central building of the castle on the

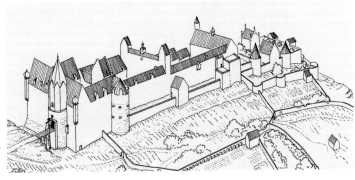

Ill. 2
Daniel Burger
The Willibalds-
burg, view from
the north-east,
c. 1600
Drawing of
reconstruction,
1999

western spur of the hill. In 1609, he began work on building a magnifi-
cent Renaissance castle, using plans drawn up by the Augsburg archi-
tect Elias Holl (1573–1646). A drawing has been preserved dated 1611,
in other words from the time of the rebuilding works, which shows the
"Gemmingen building" in an advanced stage of construction, probably
far beyond the stage it was really at, flanked by the two towers. The
draughtsman, the Augsburg aristocrat and art dealer Philipp Hainhofer
(1578–1647) commented at the time: "Your Highness wishes to turn the
entire palace round, and to have it built from blocks of rock on top of
the cliff. It is intended to roof over one side even by this summer and to
cover it all in copper. All together it will cost over 100,000 florins" (cf.
Hainhofer, 1881, p. 25). The "side" which was to be completed in the
very same year is the south wing, towering high above the mountain
crags, barely visible on the plate (cf. ill. 1).

However, Gemmingen died at the end of 1612, without com-
pleting the building. The chapter of Eichstätt cathedral transferred
the task to his successor, Johann Christoph von Westerstetten (1612–
1635/37). Wolfgang Kilian's (1561–1662) large copperplate engraving,
dated 1628, shows the result: an imposing, fortified castle, "the perfect
picture of one of the most beautiful princely residences in Germany at
that time, as well as being an important fortress"(Lochner v. Hütten-
bach, p. 24). With its numerous large windows, the castle is open to
the outside world, but it is closed to anyone looking at the picture.
Nowhere, apart from a bare forecourt, is it possible to gain a glimpse
of the inside, even of just the moat (ill. 3).

Within 50 years, the Willibaldsburg was fundamentally
changed again, from a late medieval castle to a well-fortified stately
building of the Counter-Reformation (Schaumberg), then to a stately

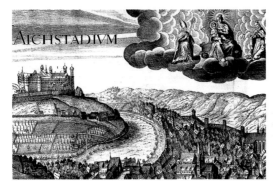

III. 3
Wolfgang Kilian
The Willibaldsburg,
view from the north,
1628
Copperplate (detail)
Eichstätt, University
Library, GS(6)3.1.60

"summer palace" of the late Renaissance period (Gemmingen) and subsequently into a magnificent fortified building (Westerstetten). Apart from a shrubbery by the old summerhouse below the front of the tower, Kilian's engraving shows no trace of the gardens for which Eichstätt castle was famous at the beginning of the 17th century and which continued to flourish around 1628, as is clear from Hainhofer's drawing.

Prince Bishop Schaumberg had already had splendid gardens laid out. A contemporary source states that he had "run walls around the castle and the gardens, also renovated the fountains and water-works and put them to better use in various places in the castle, and had made all the preparations, borders, steps, pathways and turns this necessitated". In his funeral oration for the Prince Bishop, suffragan bishop Lorentz Eiszeph praised him for having "built the new gardens, summerhouses and summer palaces so splendidly" (Leych-

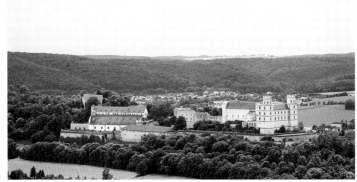

III. 4
The Willibalds-
burg, view from
the north-west,
1999

predigt, p. 16). In an obituary, the professor and poet laureate of Ingol-
stadt University, Philipp Menzel, praised the deceased for the castle
buildings and for the irrigation systems in the gardens, which were
fragrant with exotic flowers ("peregrinis halantes floribus hortos",
Turner, p. 67).

Prince Bishop Gemmingen immediately started work on de-
veloping the gardens further. Schaumberg had already filled in the
broad moat spanned by a bridge between forecastle and outworks
with vault constructions and had created a level area for the new cas-
tle building. Gemmingen set about altering the rocky rounded moun-
taintop with renewed vigour. In his dedication to Prince Bishop Gem-
mingen in the foreword to the *Hortus Eystettensis*, Besler (1613, p. IV)
praises the fact that the soil around the castle had been improved
and cultivated for many years with good earth from the valley, which
combined with the splendid development of the castle to produce a
wonderful overall picture. A summary of numerous expenses for the
gardens, namely for the rear castle garden, as well as for the adapta-
tion and furnishing of a round tower as a garden pavilion, has sur-
vived, dating from as early as 1599, ten years before work started
on the further development of the castle. In 1611, Hainhofer reports
direct from the construction site, that he "went into eight gardens
around the castle, which is situated on rock ... all of which are
arranged differently with flowerbeds, flowers, especially beautiful
roses, lilies, tulips, ... some of which are embellished with painted

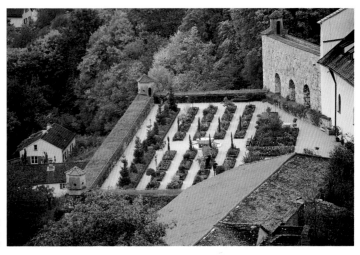

Ill. 5
The Bastion
Garden, 1999

rooms and summerhouses, including in one room a round ebony table, the leaf and foot of which are inlaid with silver engraved flowers and insects". He continues: "The gardens are all going to be turned round as well and levelled with each other around the castle" (Hainhofer, 1881, p. 24). In the quarry below the castle, Gemmingen arranged for stones to be cut and brought up, in order to relandscape the inhospitable, rocky terrain and thus to create the "eight gardens around the castle", or, as the Prince Bishop himself wrote to Duke Wilhelm V of Bavaria, to create a spacious, integrated garden from his "narrow little garden" (Hainhofer, 1881, p. 19). At the time of Hainhofer's visit, these gardens actually extended within the ramparts, around the castle and over the inner courtyards. Many of the plants in the *Hortus* that were exotic at the time are now naturalised. Even at that time, more than half were naturalised in Germany, up to a third came from the Mediterranean region, around ten per cent from Asia, mainly from the Middle East and east India, and at least five from America, with only a few plants coming from Africa. Besler had obtained some of the exotic plants, mainly from his advisers Joachim Camerarius and Carolus Clusius, while others, as the Prince Bishop tells Hainhofer, had been supplied by traders from the major commercial towns of the Low Countries.

On the belvedere ("Altane") in front of the Prince Bishop's room stood ordered rows of glass bowls and wooden troughs with plants, which the Bishop looked out onto through large, clear win-

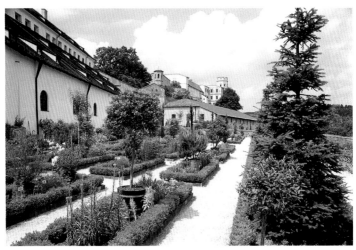

Ill. 6
The Bastion
Garden, 1999

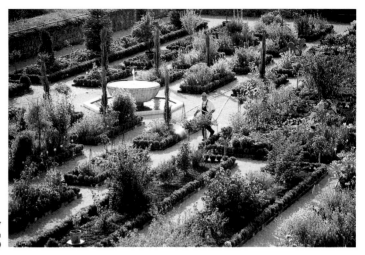

dows. Here too there were six large blocks of wood that held small desiccated trees. The Bishop explains to his visitor that in winter they act as an aviary in front of his room, for when he scatters bird food, "the birds come in flocks, often more than 200 at a time, looking for food, singing together", and he lets them fly away. However, if he tried to catch them, then he would drive them away "and his pleasure would be gone forever". Hainhofer also recorded that a water pipe led through the royal chamber to irrigate the garden, so that running water could be heard in the room. The garden itself was irrigated by means of "little wooden pillars with pipes, which conduct the water to a brook and the entire garden" (Papebroch, pp. 88–89). In the two storeys beneath the belvedere, there were treasure vaults, entry to which was gained from the antechamber of the Prince's room by a spiral staircase. The stairs led further down to the hare pit and over the bridge into the outer ward, which was laid out as a garden. The spiral staircase, known as the "botanical staircase", is fitted with wooden panelling, some of which still remains, which is painted with flowers, such as are shown in the lavishly illustrated *de luxe* edition of the *Hortus Eystettensis*. The projecting section of the belvedere with its treasure vaults and staircase appears to have been constructed only a few years before Elias Holl's so-called Gemmingen building, but still actually during Gemmingen's lifetime. The painting of the stairs was thus undoubtedly connected with the development of the garden and the drawing of the plants for the *Hortus Eystettensis*.

15

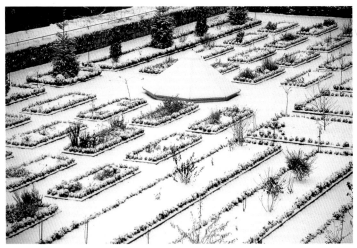

III. 8
The Bastion
Garden, 1999

This makes it possible to see Gemmingen's overall plan. The sumptuously furnished castle, the treasure vaults with their lavish plant decorations and plant-bedecked figures, as described extensively by Hainhofer, together with the gardens produce an integrated summer palace and garden, such as had developed in Italy since the 16th century, but which was still unknown in Germany at that time. It would be pleasant "to look out of the window onto many well-cultivated and maintained fields". But it would be even more beautiful and beneficial "to look out onto lovely gardens of well-balanced proportions, attractive and handsome arbours and, if possible, on to small displays and delectable borders of lavender, rosemary, box and the like; to hear the enchanting music of an infinite number of pretty little birds". So writes Charles Estiennes in his *Praedium Rusticum* (Cowell, p. 164) as early as the middle of the 16th century. Prince Bishop Gemmingen created this pleasure for himself in and around the Willibaldsburg castle as well as by means of the structure itself. He looked out through the large windows of his room over the roof garden of the belvedere and the well-proportioned, walled gardens, as described by Besler, which he had built himself, with fountains, pavilions and statues in between plants, and then further out over the Altmühl river, the villages, the meadows and the well-cultivated fields in the valley. Significantly, Hainhofer actually talks of the river Altmühl as a stretch of water, "which has been conducted right around the hill of the castle": he was even of the opinion that the river itself had been artificially

diverted. According to Hainhofer, the Prince Bishop also kept animals. There were four pheasant gardens for different coloured types of pheasant, each with its own gardener, a hare pit and some birds, most notably a nightingale. There do not seem to have been any of the otherwise customary aviaries: the birds were to be allowed to fly in and out

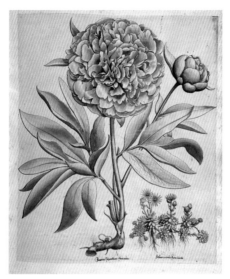

Ill. 9
Paeonia polyanthos flore rubro
Common peony
Sketch
Erlangen, University Library, E 356, Ms. 2370, Bl. 113

quite freely. A great variety of fish splashed around in the Altmühl. In addition to these living treasures, there were fossils, found in the Jura mountains through which the Altmühl flows, "fish, leaves, birds, flowers and many strange things, which Nature makes visible there" (Hainhofer, 1881, p. 26).

Around 1600, summer palaces and pleasure gardens could be found in other German cities, in Linz, Munich and Stuttgart, for example, but as a rule these were next to the actual royal residence. Thus the "Rosengart" (Rose garden) attached to the Residenz in Munich was enclosed by a three-winged building with a belvedere around its roof. People could look out from the belvedere into the large palace gardens, but not beyond. They remained in the "hortus conclusus", a

garden shut off from the outside world. It was not yet common for different elements of the landscape to be linked, as in the view from the Willibaldsburg belvedere, a style that must have further increased the elegiac atmosphere typical of a Renaissance garden. The Prince Bishop of Eichstätt, however, who by all accounts suf-

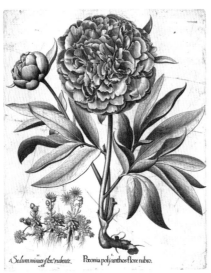

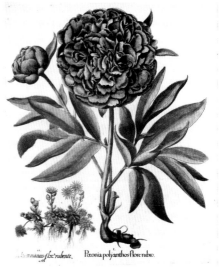

Ill. 10
Paeonia polyanthos flore rubro
Common peony
Copperplate, copy from 1998
Vienna, Graphische Sammlung Albertina

Ill. 11
Paeonia polyanthos flore rubro
Common peony
Copperplate, original colouring, 1636

fered from gout and other complaints, did not seek relaxation in a hermetically sealed garden, but, as Hainhofer reports, "had himself carried into the green fields" (Hainhofer, 1881, p. 40) to get some fresh air. Having experienced something of the beauty of the world on extensive travels through Europe during his youth, he was now inclined to compare his existence with the sufferings of Job (Hainhofer, 1881, p. 32). But unlike the latter, according to Hainhofer, Gemmingen did not complain and withdraw from life, but continued to be receptive to anything of beauty, collected it and enjoyed doing so: "this bishop's greatest recreation lies in flowers, birds, gold and precious stones" (Hainhofer, 1881, p. 154). His interests also included the magnificent illustrated florilegium

of his pleasure garden. Having possibly initially entrusted the garden design to Joachim Camerarius the Younger (1534–1598), he subsequently handed this over to the Nuremberg apothecary Basilius Besler (1561–1629), as the latter emphasises in his dedication (p. III). In 1606/07 he was also commissioned to produce the copperplate engravings. However, as with the construction of the castle and many other projects, it was not to be completed within Gemmingen's lifetime.

2. The Book

The oft-quoted authorities, Philipp Hainhofer and Basilius Besler, give the most detailed information on the development of the *Hortus Eystettensis*. Hainhofer quotes from a letter from Prince Bishop Gemmingen to Duke Wilhelm V of Bavaria stating that he had, "with regard to flowers and garden plants", [for some time] "had flowers and garden plants copied" [from his garden] "which just now I do not have to hand, but have sent them to Nuremberg, to be engraved in copper, and perhaps might like to have printed subsequently". He tells Hainhofer the same: the drawings were in Nuremberg, where "I have asked an apothecary, who is helping me establish my garden and propagate plants, and who wants to engrave it in copper, print it, dedicate it to me and thereby find fame and fortune". In his report, Hainhofer continues, "that the apothecary, Beseler, is very busy in Nuremberg working on the book, since Your Highness is sending weekly one or two boxes of fresh flowers to be copied" [and that the] "book will cost a good 3,000 fl"(Hainhofer, 1881, pp. 19 and 27 f.).

The Nuremberg apothecary Besler went into great detail about his method in the book's Latin dedication to the Prince Bishop and in the Foreword to the Reader. He describes how he obtained the required botanical knowledge through lectures and discussions with renowned botanists and had established a little garden of his own in Nuremberg, "not only to pursue plant studies more intensively and to please my patron, but also so that as is necessary the respective plants could be taken as fresh as possible for the purpose" [of drawing] (Besler, pp. III, VII). The plants sent from Eichstätt once or twice a week were not always in a sufficiently fresh condition when they arrived. Also, having a garden of his own meant that Besler could keep the troublesome transportation of plants under control.

In the Foreword to the Reader, Besler writes that for the most part the plants came directly from the Eichstätt garden, but that some also came from the Prince Bishop's estate, and the Eichstätt diocese, which stretched as far as south Nuremberg. As for the rest, he simply omitted more than 40 indigenous plants and herbs from the Prince Bishop's garden in favour of rarer and more choice ones, thereby following the example of Leonhard Fuchs (1501–1566) and Jakob Theodor Tabernaemontanus (c. 1520/30–1590), who set aesthetic considerations above botanical ones. According to his writings, he was not commissioned to make engravings of every single plant.

Following the example of his adviser, Joachim Camerarius, the work is divided into four seasons and orders, which were numbered leaf by leaf. Besler was primarily concerned with depicting the plants, at any rate the choice ones "flores & plantae istae principes", in full bloom. Small plants and those that grew in the wild are added "virtually as servants and lackeys" and as decoration to fill up the plates. The plates are therefore conceived as works of art. Even subsequent colouring was taken into account in the initial planning, as can be seen by comparison with editions that were not coloured. The smaller plants included in the plates always match the large ones in terms of colour.

In fact, colour is often the most important compositional element, as can be seen in the plate, which illustrates bear's breeches in combination with two forget-me-nots: plants that are totally different in appearance but that match each other exactly in terms of colour. Accordingly, the preliminary drawings for the copperplates, which are held at the university library, include adequate, if rather rudimentary, indications of colouring (cf. ill. 9).

Researchers have long agreed that the *Hortus Eystettensis* is of limited scientific value. It is true that the illustrations are exact, but they do not distinguish the essential from the inessential in botanical terms, a distinction already introduced by Konrad Gesner (1516–1565). But that was not Besler's intention. He primarily wanted to produce a magnificent set of plates, a florilegium, as true to nature as possible, as he stresses repeatedly. The plants were to be depicted in all their beauty, and life size. This is why he often shows the same species of plant in various stages of development, and in different forms, often just with different variations in colour. Hainhofer tells of "about five hundred" different coloured tulips in the Eichstätt Garden, of which 54 are illustrated (Hainhofer, 1881, p. 28).

20

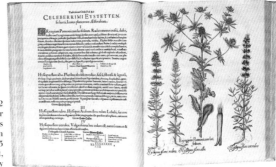

Ill. 12
Basilius Besler
Hortus Eystettensis
Text and plate from
vol. 3, plate 283
Eichstätt,
Faculty Library

For example, the large Eichstätt yellow viola (cf. p. 107), is really nothing other than a virus-infected wallflower. Although the illustration of the turk's cap lily (cf. pp. 112, 113) is spread over two pages to reproduce it life size, in many other cases part of the plant stem is cut off and tubers, bulbs or roots are shown either immediately below or alongside the top growth of the plant. In contrast, the Indian fig (cf. p. 180) is considerably reduced (but with a scale in feet at the bottom left corner of the page), while only individual branches are shown for other trees and shrubs.

Even early on, the book was criticised for the descriptions of the plants and their nomenclature, which, despite, copious literary references, were not thought to meet the standards of the time. Besler himself agrees with this criticism. He was also accused of having consulted expert assistants, such as Ludwig Jungermann (1572–1653), who was later to become professor of botany at Altdorf, on writing the text, without acknowledging them in the forewords to the *Hortus Eystettensis*. But Besler, like the widely praised Camerarius, mentions none of the many people who collaborated on the book, whether they were the draughtsmen who drew the plants from nature or who prepared the drawings for the copperplate engravings, or the copperplate engravers or the illustrators, nor does he once mention the printer(s), so that it is still not clear even today where the *Hortus* was actually printed. However, all those involved are praised *en bloc* in the *Hortus* charter of the Nuremberg Collegium Medicum, to which Besler belonged. The only people whom Besler thanks in the forewords are his two famous advisers, Joachim Camerarius the Younger and Carolus Clusius (1526–1609), sometime botanist to the imperial court and subsequently professor in Leiden, both of whom had died by the time the

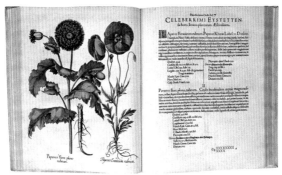

Ill. 13
Basilius Besler
Hortus Eystettensis
Text and plate from
vol. 3, plate 290
Eichstätt,
Faculty Library

book was printed, and, of course, Prince Bishop Johann Konrad, who had planned and planted much of the Eichstätt garden himself. And so, just as the garden was the Bishop's work, the overall planning and organisation of the book was "Opera Basilii Besleri", as stated on the title page (cf. p. 2). Besler also immortalised himself on the four similar interim title pages with his coat of arms and the tools of his trade. People in Eichstätt subsequently seem to have seen this as presumptuous and impertinent. They certainly had no idea of the work entailed in producing this monumental book. It would have been possible only in a city like Nuremberg, with its early industrial economic life, where several trades did the groundwork for a single maker ("publisher") and where, 120 years earlier, in the early days of book printing, Hartmann Schedel had carried out a comparable project with the *Weltchronik*.

Since plants with different flowering times are frequently combined on the plates, it can be presumed that the plants were first drawn from nature and the composition of what are known as the preliminary drawings for the engravers was decided upon only afterwards. Nicolas Barker believes he can identify Sebastian Schedel (1570–1628) as one of the draughtsmen who drew from nature. Schedel belonged to an important Nuremberg family. However, as was customary at the time, Besler also made assiduous use of the existing florilegia, especially that of Camerarius.

To date, Daniel Hertzog from Augsburg and Georg Gärtner (†1654) from Nuremberg are known by name as artists who made the preliminary drawings, while the following are known to have been among the copperplate engravers: Wolfgang Kilian also known as Dominicus (post 1550–1612) and Raphael Custos (c. 1590–1651), both

from Augsburg, and Friedrich (c. 1580–1660) and Levin van Hulsen, both resident in Nuremberg and the general area of Franconia, Peter Isselburg (c. 1580–post 1630), Dietrich Krüger (c. 1575–1624), Hieronymus Lederer (†1615), Johann Leypoldt, Servatius Raeven, G. Remus, Heinrich Ulrich (†1621) and Georg Gärtner, already mentioned as a draughtsman. Some of these names appear again as plate illuminators, together with Georg Mack the Younger († post 1622) and family from Nuremberg, and later Magdalena Fürstin (1652–1717) and Hans Thomas Fischer.

To obtain a good print of a plate, from setting up the copperplate, applying the colours and making various test prints through to achieving the successful final proof, requires a full day's work even today. Working on the basis of a similar amount of time being required around 1612/13, it would take about one and a quarter years for over 370 individual plates. Of course, multiple prints from a copperplate are quicker. But even these would produce barely more than about ten prints per day, taking into consideration all the preparation work required for the plate and paper. The plates were prepared and printed in several workshops in various locations, of which Augsburg and Nuremberg are known for certain. This would reduce the overall amount of time required accordingly. But dividing up the work between the various workshops and towns required difficult planning. This was Besler's task, as was the organisation of all the other work, from obtaining the plants from Eichstätt or from his own garden in Nuremberg and preparing them for copying, through to the engraving and printing and subsequent colouring work. It was clearly very advantageous for him for the drawing, engraving, printing and colouring to be all carried out in Nuremberg by the same craftsmen, so that no further craftsmen's guilds had to be called in.

The book printers, however, were a guild of craftsmen in their own right. They had to be engaged and taken into account separately. The question of where the *Hortus* text was printed has met with various answers. The

Ill. 14
Basilius Besler
Hortus Eystettensis, 3 vols.,
Nuremberg 1613

This edition of the *Hortus Eystettensis* is a Royal Folio measuring 57 x 46 cm. The volumes contain 584 pages altogether, of which 373 are plates.

The first volume of the Eichstätt exemplar deals with spring (plates 1–134), the second with summer (plates 135–261) and the third volume late summer, autumn and winter (plates 262–367).

The first edition consisted of 300 copies and the monochrome version cost 48 florins, while the hand-coloured edition cost 500 florins, roughly the same as a small house.

most convincing is Barker's theory that several printers were involved.

A consequence of the huge format of the *Hortus Eystettensis* (Royal folio = 57 x 46cm) was that the text pages also had to be printed singly. Two editions were produced. In the plain one, the copperplate engraving was printed on the recto of a leaf, with the text for the following plate being printed on the reverse side. In the *de luxe* version, the reverse sides of the plates were left blank and a text page, printed on both sides, was inserted between every two illustrated pages. The plates are assigned to the appropriate accompanying text page, so that the text accompanying a verso plate is on the right while the text to the following plate is on the left (cf. ills. 12, 13).

The double-sided printed edition was intended for the book trade, while the *de luxe* version, all copies of which were to be coloured, was intended for the requirements of the Prince Bishop. Unlike the *de luxe* version, in the case of the standard edition rejects were anticipated in the second printing stage, regardless of whether the copperplate engraving or the text was printed first. Adding text pages to the plates thus involved a considerable extra organisational and financial burden for the makers. It is clear that Besler became involved with this only at the insistence of the Prince Bishop and other people, the experts he refers to in his Foreword to the Reader.

There is another problem. Apart from what is known as the signature (section number) on the bottom of the text pages, there are no page or leaf numbers. The text pages show only the order (within the season) and the appropriate folio number, so that text and illustration can be correctly compiled only by using the index. The book was not sold bound or as a book block, but as loose leaves, comprising a title page, a further ten pages with dedication, foreword etc., four interim title pages, and a multi-page index to the individual seasons together with 367 or 551 leaves of plates and text. The bookbinder, who usually received clear sections, thus had to collate the pages in the correct order first into sheets (of two pages each) and then into fascicles (four sheets laid in order one on top of the other). This was an extremely laborious task. It is no wonder that mistakes were frequent. There are complaints in the correspondence with Hainhofer, who had obtained copies for several princes. On 6th April 1617, he writes to Duke August the Younger of Brunswick (Braunschweig-Lüneberg): "I have had the flower book bound, and as it has once again proved to have defects ... although even 100 fumbling book-

binders could not collate this book if they had not seen a comple copy of it" (Hainhofer, 1984, p. 198, no. 304). Besler must rapidly have come to hear of these complaints with alarming frequency. Understandably, he still tried to realise his wish of producing an edition with no text. Prince Bishop Gemmingen died on 7th November 1612, a good six months before the work was published. On 23rd August 1613, Besler dedicated an edition without text to his successor, Prince Bishop Johann Christoph von Westerstetten, stating that the other version was too expensive for the buyers. He said people were also querying the usefulness of the obsolete literature it quoted, especially since the plants it showed were reduced in scale, whereas here they were for the first time shown life-size. With this dedication, Besler managed to involve his dead patron's successor in the project to publish a new edition. According to later records, by the time of his death Gemmingen had contributed 7,500 florins. The total cost is estimated at 17,920 florins. Thus Westerstetten must have donated a good 10,000 florins more. In return, an edition without text was dedicated to him for the obvious reason that he was definitely not so well-versed in botany as his predecessor.

In 1613, three different editions were therefore published, two with accompanying texts to the plates and one without text. According to Barker, the more impressive version with text was produced only after the standard version, in any case after October 1613. The edition without text must likewise have appeared in 1613, perhaps even just before the de luxe version. Any attempt to differentiate between different impressions is therefore futile. It is better to say that all three editions together must have produced 300 copies, the figure recorded at the time. It is better to speak of one impression in three different editions, in the same way, for example, as practically 200 years later Göschen issued a complete edition of the works of Christoph Martin Wieland in four versions at the same time. At any rate, in the 1640 reprint, the three editions were described as being a first impression. The monochrome edition cost 35 florins, 48 if bound (the costs of binding could hardly have amounted to 13 florins), while the coloured edition cost 500 florins, roughly the same as a small house in Nuremberg or Munich (Hainhofer, 1984, p. 39 f., no. 26, 198, no. 304).

There are references in the literature to a 1627 edition. However, this is possibly just a florilegium of a few (possibly surplus pages) of the *Hortus*, a few copies of which were compiled for Besler's colleagues who had helped him, among other things, with the *Hortus*

Eystettensis. Today, a further two copies of different sizes are known, one in the Hessische Landes-und Universitätsbibliothek in Darmstadt, with 96 plates, and the other, with 23 plates, which was auctioned at Sotheby's in London on 27/28th April 1987.

The next reprint appeared during the Thirty Years War under Prince Bishop Marquard II Schenk von Castell (1636–1685). The garden itself then fell into disrepair, and with the financial resources of the diocese being required for the renovation of the royal palace, destroyed in 1633, a new edition was bravely published in the hope that the *de luxe* version, which had by this time become well-known throughout Germany, would sell well in France, the Low Countries and England. Thus the foreword to this edition reads:

> *This Garden of Eichstätt,*
> *Created in the Golden Age,*
> *In brazen letters displayed,*
> *Renovated in the Iron Years.* (Foreword, p. IV)

This edition has no text, as, according to the foreword, experts considered it to be quite inaccurate or at best superficial – which was Besler's own argument for the edition without text! The order is retained, except that the winter plants are assigned to autumn, so that there are now only three sections.

Prince Bishop Johann Anton I Knebel von Katzenelnbogen (1705–1725), who also wanted to renovate the garden, which had run wild, planned an anniversary edition in 1713. It was to have been extended by a few plates prepared from preliminary drawings by the Ingolstadt professor of medicine and botany, Johann Michael Hertel (c. 1650–1740). Various difficulties must have arisen, however, with the result that the project came to a halt shortly before completion. It was not until 1746 that the project was completed by the Prince Bishop's personal physician, Johann Georg Starckmann (1701–1780), with the support of the Nuremberg doctor, Christoph Jacob Trew (1695–1769). The texts were reset with a few alterations, although the title page prepared for the 1713 edition remained unchanged, which is why this edition shows the year of publication as being 1713. It was printed at the Strauss court bookbinders in Eichstätt. Apart from a few advance copies actually issued in 1713, this edition was published around 1750. It is not known how many copies were printed or how much they cost. At any rate, fifty years later, numerous copies were

Ill. 15
Advertisement of 25 April 1803 for the 1750 edition of the *Hortus Eystettensis* Gnädigst-Privilegirtes Großherzoglich-Toskanisches Eichstätter-Intelligenz-Blatt, 1803, no. XVII, p. 2

still available, which people tried to sell with little success. Thus on Wednesday, 25th April 1803, a sales promotion was announced in the Eichstätt newspaper, although it was called off again soon after, on 29th June 1803 (cf. ill. 15).

By the time of Linnaeus' new plant classification system, the classification of the *Hortus Eystettensis* had become hopelessly outdated. The Eichstätt doctor Franz Seraph Widnmann therefore brought out a concordance with the Linnaean system in Nuremberg in 1805, which appeared in Eichstätt in a French translation with a dedication to Empress Josephine in 1806. It was sold with the *Hortus* of 1750. It did not do well. The population was hard up after paying endless contributions to the war. In the year 1817, 86 publisher's copies of the *Hortus Eystettensis* remained unsold.

For a long time the copperplates of the *Hortus* were thought to have been lost. They were said to have been melted down after 1820 in the Munich mint. In 1998, it became known that 329 original plates, including the title copperplate, had been discovered during the reorganisation of the storage of artefacts in Vienna's Albertina Graphic Collection. The whereabouts of the other plates is not known. It is unclear how the plates got to Vienna. It seems that they came to

Salzburg, and later to Vienna, in 1803 when the Deputation of the German Estates decided to compensate German sovereign princes for the losses of territories ceded to France, thereby awarding Eichstätt, which had now lost its ecclesiastical status, to Archduke Ferdinand of Salzburg-Toscana. At the end of 1802, when Bavaria first wanted to include Eichstätt, the plates had been removed to Bavarian Neuburg/ Donau, as Interims-Hofmarschall Ignaz Frhr von Zweyer reported to the Salzburg government in Eichstätt on 3rd March 1803. The archducal government probably asked for them to be returned, not to Eichstätt, but, because of their size (approx. 49 x 40 cm) and their considerable weight (about 4 kg), straight to Salzburg via the Danube, Inn and Salzach rivers or direct to Vienna.

A small section of the former gardens has been restored based on the *Hortus Eystettensis* and opened to the public as a "bastion garden" at the Willibaldsburg castle.

3. PORTRAYAL OF PARADISE

In the foreword to the *New vollkommen Kräuter-Buchs* by Jakob Theodor Tabernaemontanus, edited by Caspar and Hieronymus Bauhin and published in 1664, it is stated that the "Herbs" and "plants of the earth" are solely for human use, "initially admittedly partly and particularly for food, partly for pleasure, but subsequently, after the Fall of Man, also for clothing and medicine".

The Nuremberg botanist Joachim Camerarius, whom Besler regarded as an authority, expressed it quite differently in his foreword to Pier Andrea Matthioli's *Kreutterbuch*, which he had translated and edited, several editions of which were published after 1586. According to him, when man contemplates the grasses, herbs and trees of the third stage of the Creation, it would force him to praise God. Carolus Clusius, whom Besler had originally recommended to the Eichstätt Prince Bishop as editor of the *Hortus Eystettensis*, expressed it even more clearly in 1601 on the title page of his florilegium *Rariora plantarum historia*. It shows an epitaph, with the title in the middle, the motto "virtute et ingenio" underneath, and the sentence "plantae cuique suas vires deus indidit, atque praesentem esse illum, quaelibet herba docet" above, "God gave to each plant its strength and each plant proves that He is present". To the left and right stand the Old Testament figures of Adam and Solomon, while below sit the Classical botanists Theophrastus and Dioscourides. The scene is crowned by

the divine pillar of fire and cloud from the Old Testament with God's name in Hebrew (cf. ill. 16).

These are reversed in the title copperplate of the *Hortus Eystettensis*. A portico, a temple porch, dominates the picture. It is flanked by twisting double pillars whose design was inspired by the pillars in the Temple of Solomon. As in Gothic and Renaissance churches, a cloth is stretched between them, on which the title of the book is displayed. Below, the view opens out into paradise, into which God is leading Man, so that he, as their master, may give the animals names and cultivate the Garden of Eden. Solomon and Cyrus are positioned to the side of the columns. King Solomon could speak just as knowledgeably about the cedars of Lebanon as he could about the hyssop, which grows as a weed on the walls (Kings 5, 13). Cyrus, the powerful king of Persia, was also amazingly well-versed in horticulture, and had himself laid out a famous garden and planted trees, as Cicero writes in *De senectute* (Chap. 17). Besler also refers to these passages in his dedication to the Prince Bishop (p. II). On the far left, on pedestals as tall as the kings stands a Indian fig (*Opuntia ficus-Indica*), to the right a century plant, both imported from America in the 16th century. Crowning them all is the coat of arms of the Eichstätt Prince Bishop Johann Konrad von Gemmingen.

On the left-hand side of the portal rests flower-bedecked Flora holding freshly picked flowers in her right arm and a wicker basket full of flowers in her left, a symbol of abundant wealth and prosperity. To the right sits Ceres holding an olive branch in her left arm and a beehive in her right. The olive branch is a symbol of the reconciliation between God and Man and God's promise after the Flood that the earth would once again bring forth life and would once again be fertile. The beehive symbolises an abundance of wealth and gifts, arising from the diligence and care of its inhabitants. The flower basket and the beehive are handmade, the flower basket for the enjoyment of blossoming flowers, the beehive so as to be able to make use of the flowers, through the bees. Bunches of fruit hang down from the feet of both goddesses.

The range of this title page is astonishing: the coat of arms is there to honour Prince Bishop Johann Konrad von Gemmingen, a reliable authority on garden cultivation who commissioned and was involved in the development of his famous garden, as the man of the piece. Space and time, the exotic plants and the classical kings so well-versed in botany, even the Old Testament God himself with his

Creation; all refer to the Bishop and his creation (Besler, pp. II-IV). In 1713, either people no longer dared or else no longer understood, and the Gemmingen coat of arms was replaced with that of the Prince Bishopric of Eichstätt, with the coat of arms of the then Prince Bishop being shown much smaller under the architrave. In the title, on the

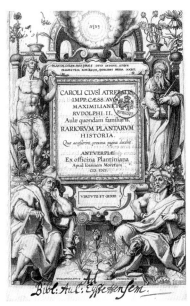

Ill. 16
Carolus Clusius
Rariorum plantarum historia, 1601,
title page

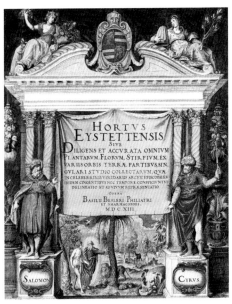

Ill. 17
Basilius Besler
Hortus Eystettensis, 1613
title page

other hand, the Prince Bishop as Commissioner ("curis episcopi") assumes Besler's place as maker ("opera Besleri"). Incidentally, Besler ceased to be mentioned as early as the 1640 reprint.

The tapestry with the book title between the pillars of Solomon is reminiscent of the curtain of the temple, behind which the Ark of the Covenant was hidden. The *Hortus Eystettensis* curtain proclaims the plant book that illustrates the world of plants to the life, so that, as in the Eichstätt garden, botanical studies can be pursued using the illustrations, without incurring the great expense of the lengthy journeys that would otherwise be necessary (Besler, p. IV). The *Hortus* is grouped into four seasons. The dedication to Prince Bishop Gemmin-

gen dates from spring 1612, a leap year with 366 days. It was probably intended to publish the book that year. The *Hortus Eystettensis* contains 366 plates with plant pictures, counting as one page plates 181–182 which make up one illustration. Just as the Eichstätt garden, established with such great efforts on the instructions of the Eichstätt Prince Bishop, included flora and fauna from the surrounding area and from the early geological period, so the *de luxe* version of the *Hortus Eystettensis Eystettensis* encompasses time and space by external classification, through the number of plates and the selection of the illustrated plants. Both the garden and the book were a portrayal of paradise.

PLANTARVM.

HORTI EYSTÆT

TENSIS.

Claſſis Verna.

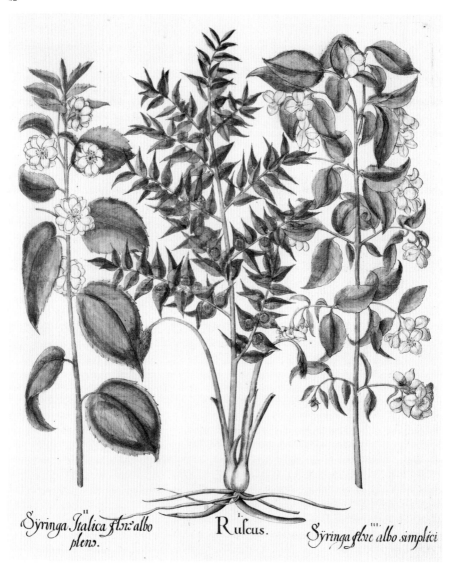

Syringa Italica flor. albo plen. *Ruscus.* *Syringa flore albo simplici*

II. PHILADELPHUS CORONARIUS
Mock orange

I. RUSCUS ACULEATUS
Butcher's broom; Box holly;
Jew's myrtle

III. PHILADELPHUS
CORONARIUS
Mock orange

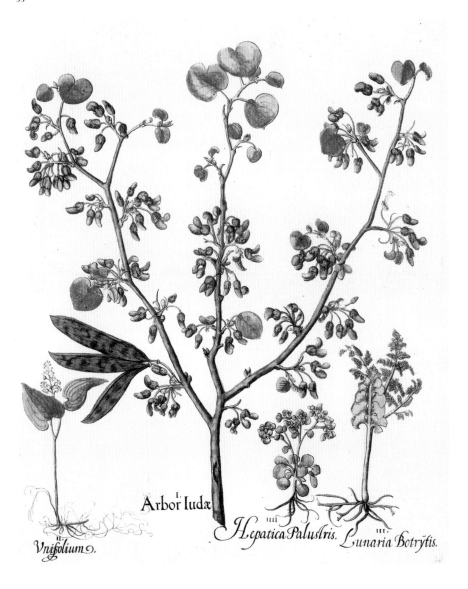

Arbor Iudæ

Hepatica Palustris. Lunaria Botrÿtis.

Vnifolium.

II. MAIANTHEMUM
BIFOLIUM
False lily of the vally

I. CERCIS
SILIQUASTRUM
Judas tree; Love tree

IIII. CHRYSOSPLENIUM
OPPOSITIFOLIUM
Golden saxifrage

III. BOTRYCHIUM
LUNARIA
Common moonwort

II.
Anagyris latifolÿs.

I.
Anagyris angustifoliis.

II. LABURNUM ALPINUM
Scotch laburnum; Alpine golden chain

I. LABURNUM ANAGYROIDES
Common laburnum; Golden chain

III.
Clematis Daphnoides.
flore cæruleo.

II.
Clematis Daphnoides
flore albo.

I.
Staphylodendron.

V.
Clematis Daphnoides
flore purpureo pleno.

IIII.
Clematis Daphnoides
flore purpureo.

III. VINCA MINOR
Lesser periwinkle

I. STAPHYLEA PINNATA
Bladdernut

II. VINCA MINOR
Lesser periwinkle

V. VINCA MINOR
Lesser periwinkle

IIII. VINCA MINOR
Lesser periwinkle

Lychnis viscosa sylvestris flore incarnato.

Poma flore multiplici.

Rapunculus Sylvestris maior

II. LYCHNIS VISCARIA
German catchfly

I. MALUS SPEC.
Double apple blossom

III. CAMPANULA PATULA
Bellflower

I.
Sambucus arborrosea.

II.
Trifolium arborescens.

III.
Cytisus V. Clusy.

II. CYTISUS SESSILIFOLIUS
Broom

I. VIBURNUM OPULUS
Snowball bush; Guelder rose;
European cranberry bush

III. CYTISUS CILIATUS
Broom

II.

Ligustrum.

I.

Guaiacana.

II. LIGUSTRUM VULGARE
Common privet

I. DIOSPYROS LOTUS
Date plum

Ribes fructu albo.

Ribes maior fructu rubro.

Ribes fructu nigro.

Ribes minor fructu rubro.

Ribes vulgaris fructu rubro.

V. RIBES RUBRUM
Red currant

III. RIBES NIGRUM
Black currant

I. RIBES ALPINUM
Alpine currant; Mountain currant

IIII. RIBES RUBRUM
Red currant

II. RIBES RUBRUM
Red currant

III. ERYTHRONIUM DENS-CANIS
European dog's-tooth violet

V. PRIMULA VULGARIS
Primrose

I. LATHRAEA SQUAMARIA
Toothwort

II. ERYTHRONIUM DENS-CANIS
European dog's-tooth violet

IIII. PULMONARIA OFFICINALIS
*Jerusalem cowslip; Soldiers and
sailors; Spotted dog*

Auricula Ursi flore purpureo.

Auricula Ursi flore albo.

Auricula Ursi flore luteo.

Fistolochia flore albo.

Ranunculus Sylvarum flore albo & pleno.

II. PRIMULA AURICULA
Alpine auricula

I. PRIMULA AURICULA
Alpine auricula

III. PRIMULA AURICULA
Alpine auricula

IIII. CORYDALIS CAVA
Hollow-rooted corydalis

V. ANEMONE NEMOROSA
Windflower; Wood anemone

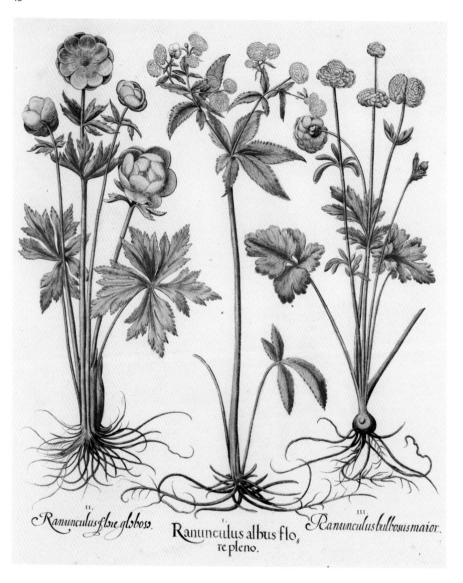

II. *Ranunculus flore globoso.*

I. *Ranunculus albus flo, re pleno.*

III. *Ranunculus bulbosus maior.*

II. TROLLIUS EUROPAEUS
European globe-flower

I. RANUNCULUS
ACONITIFOLIUS
Bachelor's buttons;
Fair maids of France;
Fair maids of Kent

III. RANUNCULUS BULBOSUS
Bulbous buttercup; Crowfoot

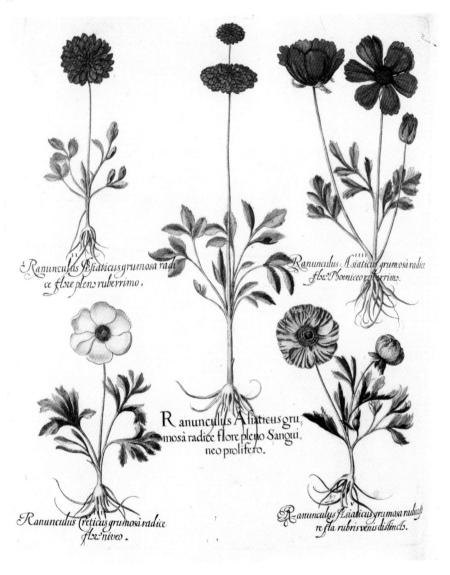

Ranunculus Asiaticus grumosa radi
ce flore plens ruberrimo.

Ranunculus Asiaticus grumosa radice
flore Phoeniceo ruberrimo.

Ranunculus Asiaticus gru
mosa radice flore pleno Sangui,
neo prolifero.

Ranunculus Creticus grumosa radice
flore niveo.

Ranunculus Asiaticus grumosa radice
re fla rubris venis distincts.

II. RANUNCULUS SPEC.
Asian buttercup; Crowfoot

I. RANUNCULUS SPEC.
Asian buttercup; Crowfoot

IIII. RANUNCULUS SPEC.
Asian buttercup; Crowfoot

III. RANUNCULUS SPEC.
Asian buttercup; Crowfoot

V. RANUNCULUS SPEC.
Asian buttercup; Crowfoot

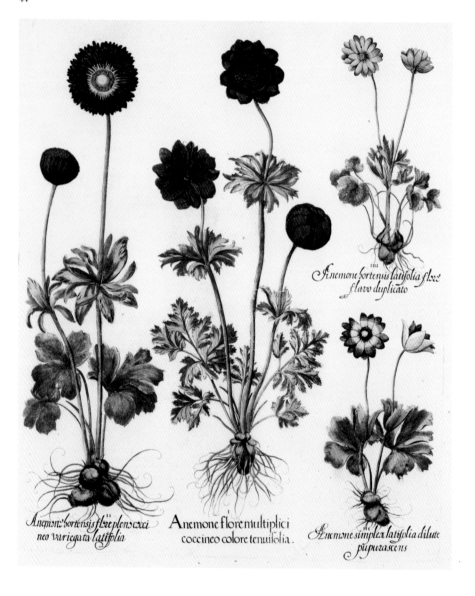

IIII.
Anemone hortensis latifolia fl.xc. fl.lavo duplicato

Anemonc hortensis fl.xc plens.cxci neo variegata latifolia

Anemone flore multiplici coccineo colore tenuifolia.

III.
Anemone simplex latifolia dilute pupurascens

II. ANEMONE SPEC.
Windflower

I. ANEMONE SPEC.
Windflower

IIII. ANEMONE PALMATA
Windflower

III. ANEMONE HORTENSIS
Windflower

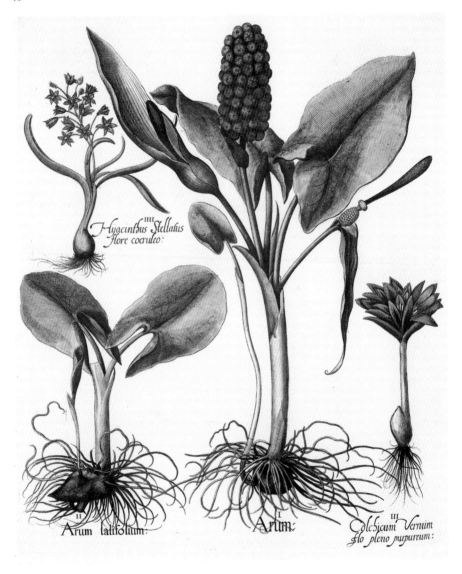

Hyacinthus Stellatus Flore coeruleo:

II. *Arum latifolium:*

I. *Arum:*

III. *Colchicum Vernum flo pleno purpureum:*

IIII. SCILLA AMOENA
Squill

I. ARUM MACULATUM
*Lords-and-ladies; Cuckoo-pint;
Jack-in-the-pulpit*

III. BULBOCODIUM VERNUM
Spring meadow saffron

II. ARUM MACULATUM
*Lords-and-ladies; Cuckoo-pint;
Jack-in-the-pulpit*

46

Crocus Vernus
flore violaceo.

Crocus Vernus flos
candido.

Hepatica Aurea
flore rubro.

I.
Scilla Alba.

Hepatica Aurea
flore coeruleo.

III. CROCUS VERNUS
Crocus

I. URGINEA MARITIMA
Sea onion; Squill

II. CROCUS VERNUS
Crocus

V. HEPATICA NOBILIS
Blue anemone

IIII. HEPATICA NOBILIS
Blue anemone

47

III. *Hyacinthus Orientalis mixtus.*

I. *Ornithogalum minus.*

II. *Hyacinthus Orientalis variegatus.*

III. HYACINTHUS ORIENTALIS
Milk-blue hyacinth

I. ORNITHOGALUM
UMBELLATUM
Star-of-Bethlehem

II. HYACINTHUS ORIENTALIS
Dark red hyacinth

48

Palma Christi fl.x. purpur. *Hyacinthus stellatus* *Orchis minor fl.x. incarnata.*
peruanus.

III. DACTYLORHIZA MAJALIS
Broad-leaved marsh orchid

I. SCILLA PERUVIANA
Squill of Peru

II. ORCHIS TRIDENTATA
Toothed orchid

III.
Muscari flore obsoleto ni-
gro.

I.
Hyacinthus Botryoides
Maior.

II.
Nuscari flore obsoleto
albo.

III. MUSCARI MOSCHATUM
Grape hyacinth

I. MUSCARI NEGLECTUM
Common grape hyacinth

II. MUSCARI MOSCHATUM
Grape hyacinth

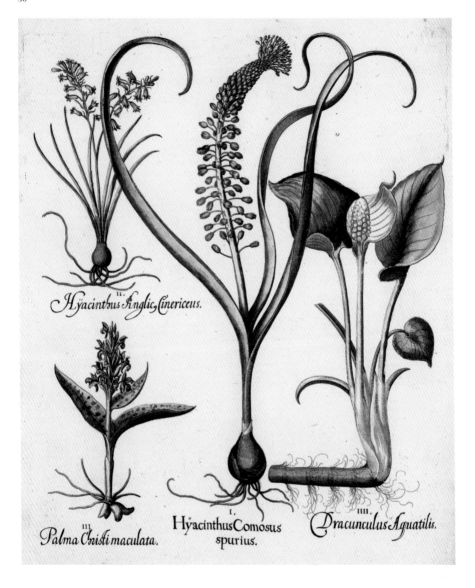

Hyacinthus Anglic. Cinericeus.

Palma Christi maculata.

I.
Hyacinthus Comosus
spurius.

IIII.
Dracunculus Aquatilis.

II. HYACINTHOIDES
NON-SCRIPTA
Bluebell

III. DACTYLORHIZA MACULATA
Marsh orchid

I. MUSCARI COMOSUM
Tassel grape hyacinth

IIII. CALLA PALUSTRIS
Bog arum; Water arum;
Wild calla; Water dragon

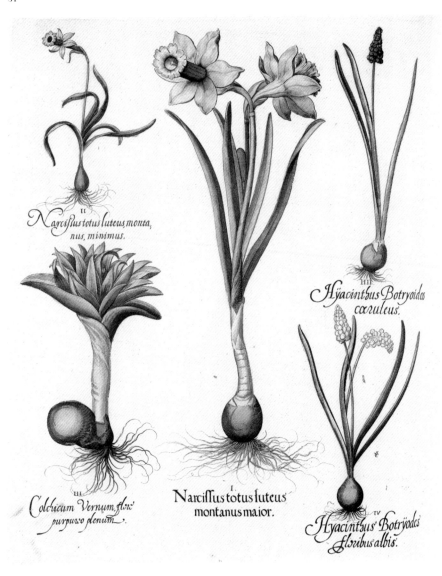

Narciſſus totus luteus monta,
nus, minimus.

Hyacinthus Botryoides
cœruleus.

Colchicum Vernum, flor:
purpureo plenum.

Narciſſus totus luteus
montanus maior.

Hyacinthus Botryodes
floribus albis.

II. NARCISSUS PSEUDONARCISSUS
Lent lily; Wild daffodil;
Trumpet narcissus

III. BULBOCODIUM VERNUM
Spring meadow saffron

I. NARCISSUS
PSEUDONARCISSUS
Lent lily; Wild daffodil;
Trumpet narcissus

IIII. MUSCARI BOTRYOIDES
Grape hyacinth

V. MUSCARI BOTRYOIDES
Grape hyacinth

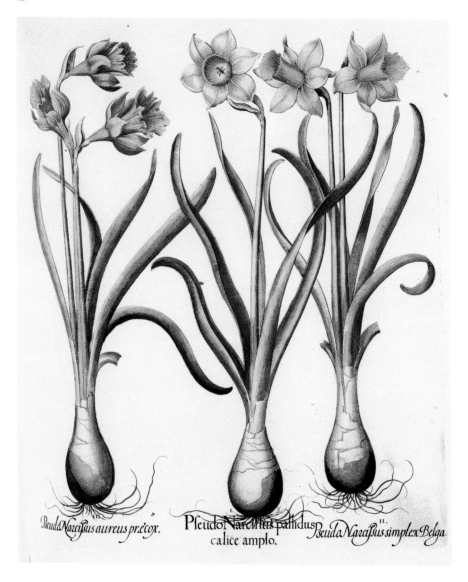

Pseuda Narcissus aureus præcox.

Pseudo Narcissus pallidus calice amplo.

Pseuda Narcissus simplex Belga.

III. NARCISSUS
PSEUDONARCISSUS
*Lent lily; Wild daffodil;
Trumpet narcissus*

I. NARCISSUS ×
INCOMPARABILIS
Daffodil

II. NARCISSUS ×
INCOMPARABILIS
Daffodil

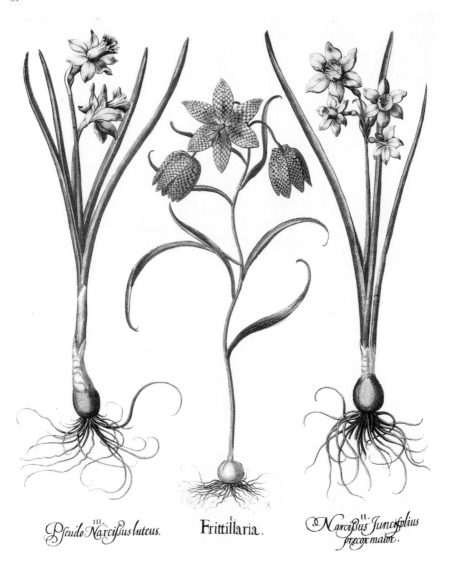

Pseudo Narcissus luteus. Frittillaria. *Narcissus Juncifolius precox maior.*

III. NARCISSUS
PSEUDONARCISSUS
Lent lily; Wild daffodil;
Trumpet narcissus

I. FRITILLARIA MELEAGRIS
Snake's head fritillary;
Guinea-hen flower;
Chequered lily; Leper lily

II. NARCISSUS JONQUILLA
Jonquil

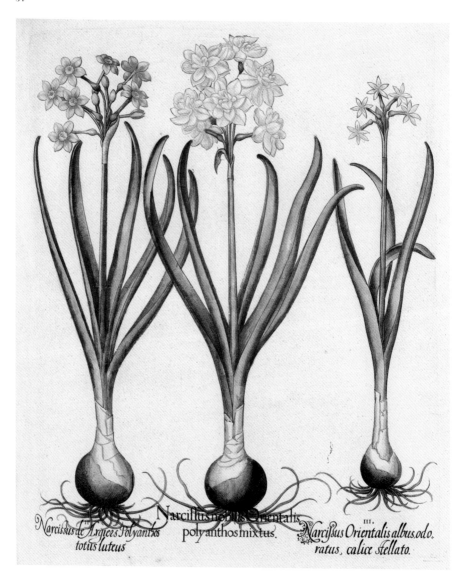

II. NARCISSUS AUREUS
Yellow daffodil

I. NARCISSUS TAZETTA
Bunch-flowered narcissus;
Polyanthus narcissus

III. NARCISSUS SPEC.
White-blue daffodil

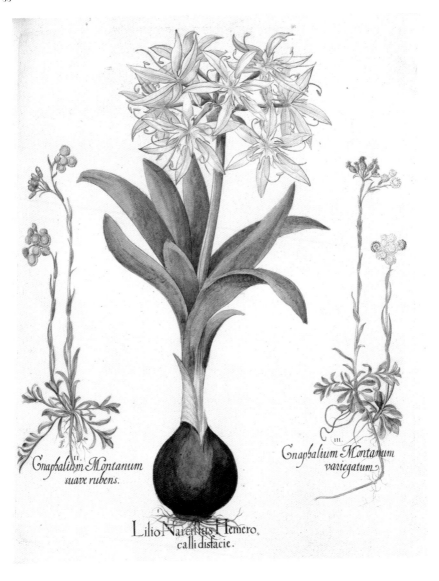

Gnaphalium Montanum
suave rubens.

Gnaphalium Montanum
variegatum.

Lilio Narcissus Hemero,
callidisfacie.

II. ANTENNARIA DIOICA
Cat's ears; Pussy-toes

I. PANCRATIUM ILLYRICUM
Sea lily

III. ANTENNARIA DIOICA
Cat's ears; Pussy-toes

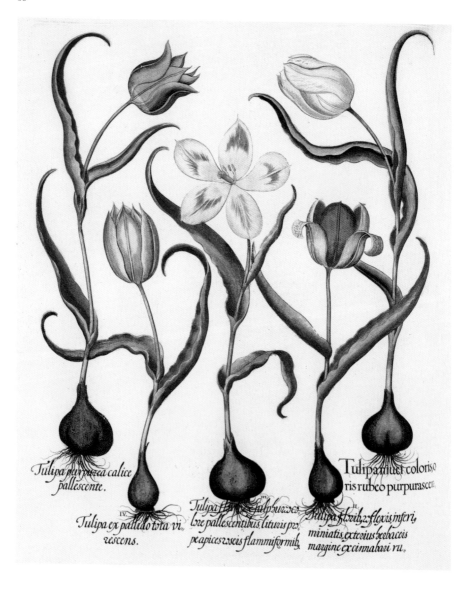

Tulipa purpurea calice
pallescente.

Tulipamuli coloriso
ris rubeo purpurascen.

Tulipa flore sulphureo
lore pallescentibus lituris pro
peapices roseis flammiformib.

Tulipa floribz flexis inferi,
miniatis, exterius beebacceis
margine excinnabari ru.

Tulipa ex pallido tota vi
rescens.

V. TULIPA SPEC.
*Gesneriana hybrid
with yellow base*

IIII. TULIPA
SPEC.
Species tulip, green

III. TULIPA
SPEC.
*Yellow-flamed
tulip*

II. TULIPA SPEC.
*Early, carmine-red
tulip with large
yellow petals*

I. TULIPA SPEC.
*Late, white,
red-margined
tulip, fringed*

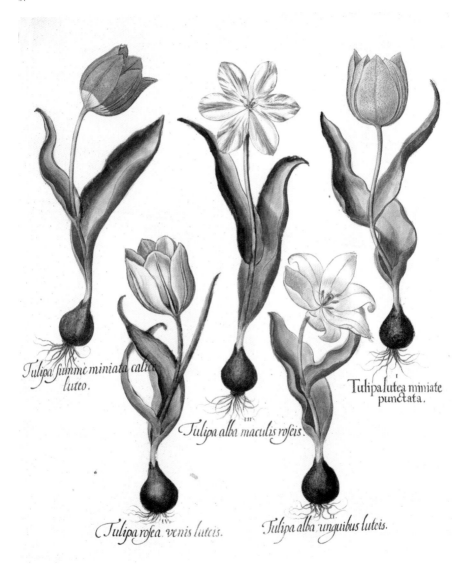

Tulipa summe miniata calice luteo.

Tulipa lutea miniate punctata.

Tulipa alba maculis roseis.

Tulipa rosea, venis luteis.

Tulipa alba unguibus luteis.

V. TULIPA SPEC.
*Gesneriana hybrid
with yellow base*

IIII. TULIPA
SPEC.
*Pink tulip, finely
veined yellow*

III. TULIPA
SPEC.
*Early, white tulip,
purple striped*

II. TULIPA SPEC.
*Early, white tulip,
yellow inside*

I. TULIPA SPEC.
*Early, yellow,
purple flecked
tulip*

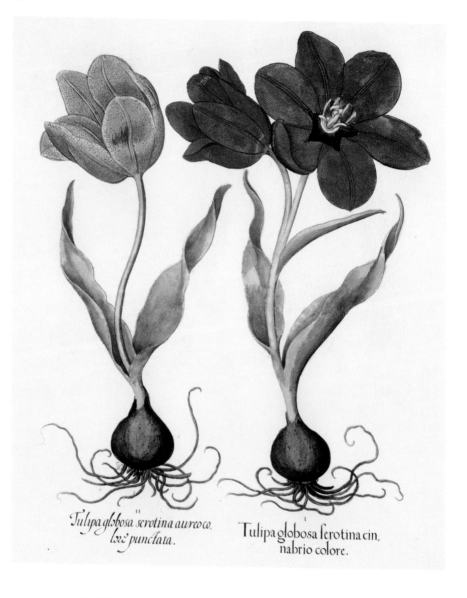

Tulipa globosa serotina aureo co.
lore punctata.

Tulipa globosa serotina cin.
nabrio colore.

II. TULIPA SPEC.
Tulip with yellow-feathered petals

I. TULIPA SPEC.
Late tulip with large red flower

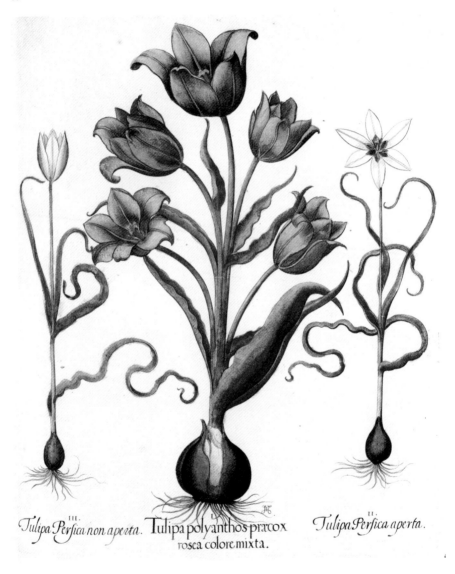

Tulipa Perſica non aperta. Tulipa polyanthos præcox rosea colore mixta. *Tulipa Perſica aperta.*

III. TULIPA SPEC.
*White botanical tulip,
flower closed*

I. TULIPA SPEC.
Multi-flowered red tulip

II. TULIPA SPEC.
White botanical tulip, flower open

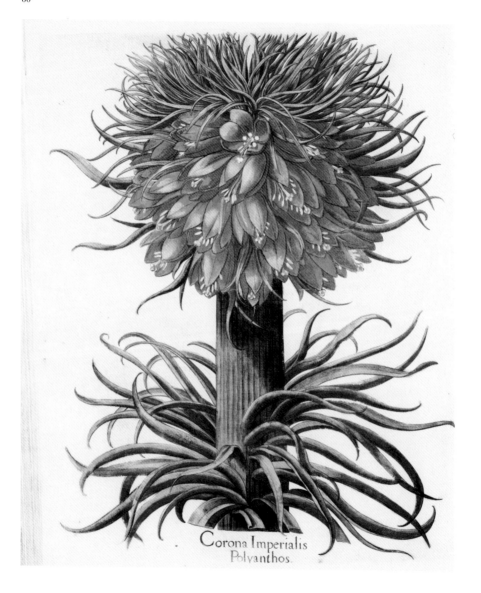

Corona Imperialis
Polyanthos.

FRITILLARIA IMPERIALIS
Multi-flowered crown imperial

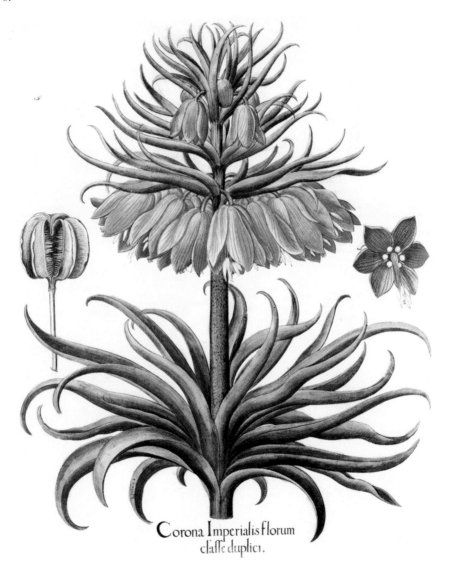

Corona Imperialis florum
claſſe duplici.

FRITILLARIA IMPERIALIS
Crown imperial with two crowns

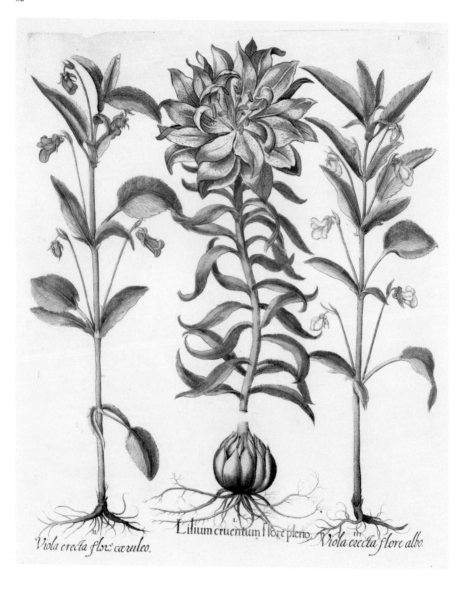

Viola erecta flore cæruleo. Lilium cruentum flore pleno. Viola erecta flore albo.

II. VIOLA ELATIOR
Violet

I. LILIUM BULBIFERUM
Fire lily

III. VIOLA ELATIOR
Violet

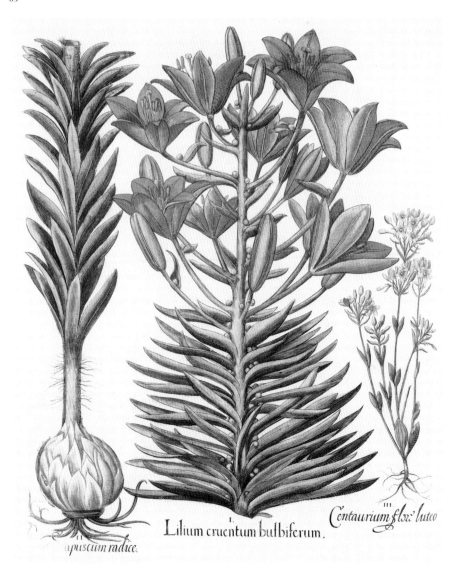

Lilium cruentum bulbiferum.

Centaurium flor. luteo

apuscum radice.

II. LILIUM BULBIFERUM SSP.
BULBIFERUM
*Bulbil-producing varietas
with bulb*

I. LILIUM BULBIFERUM SSP.
BULBIFERUM
*Bulbil-producing varietas
with bulb*

III. BLACKSTONIA SEROTINA
Yellow-wort

Centaurium minus flox albo.

Lilium cruentum polyanthos

Centaurium minus flox rubro.

III. CENTAURIUM ERYTHRAEA
Common centaury

I. LILIUM BULBIFERUM
Proliferation of fire lily

II. CENTAURIUM ERYTHRAEA
Common centaury

Veronica recta cærulea.

Sultan Zambach Mar-
tagon Constantinopoli,
tantum flore albo.

Bulbus Sultan Zambach,
cum inferiori parte caulis.

II. VERONICA LONGIFOLIA
Speedwell; Bird's-eye

I. LILIUM CANDIDUM
Madonna lily; White lily with bulb

III. LILIUM CANDIDUM
Madonna lily; White lily with bulb

Trifolium Acetosum flor: albo. Rosa Damascena flore pleno. Trifolium Acetosum flor: flavo.

II. OXALIS ACETOSELLA
Wood sorrel; Cuckoo bread;
Alleluia

I. ROSA SPEC.
White rose

III. OXALIS CORNICULATA
Procumbent yellow sorrel;
Creeping oxalis

Rosa lutea maxima flore
pleno

Rosa provincialis flore in
carto pleno.

Rosa centifolia rubra.

Rosa prænestina variegata.

IIII. ROSA HEMISPHAERICA
Sulphur rose

III. ROSA GALLICA OFFICINALIS
Apothecary's rose; Red rose of Lancaster

I. ROSA CENTIFOLIA
Provence rose

II. ROSA GALLICA OFFICINALIS-VERSICOLOR
Rosa mundi

IV.
Rosa provincialis flor: albo.

III.
Rosa Milesia flor: rubro olens.

II.
Rosa alba flore simplici.

I.
Rosa flore albo pleno.

IIII. ROSA SPEC.
White rose

III. ROSA GALLICA
Red rose; French rose

II. ROSA × ALBA
Single white rose; Single white rose of York

I. ROSA × ALBA
Double white rose; Double white rose of York

Rosa præcox spinosa flore albo. IV.

Rosa rubra præcox flore simplici. III.

Rosa Cinnamomea. II.

Rosa lutea flore simplici. I.

IIII. ROSA SPINOSISSIMA
Burnet rose; Scotch rose

III. ROSA PENDULINA
Red Alpine rose

II. ROSA MAJALIS
Whitsuntide rose; May rose

I. ROSA FOETIDA
Austrian yellow rose; Austrian briar

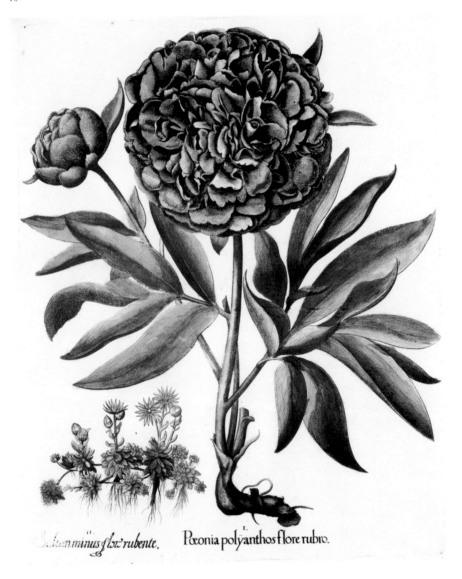

Sedum minus flore rubente. Pæonia polyanthos flore rubro.

II. SEMPERVIVUM MONTANUM
Alpine houseleek

I. PAEONIA OFFICINALIS
Double common peony

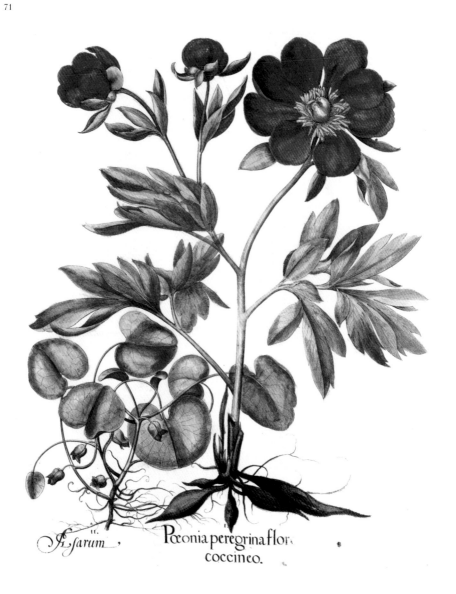

Asarum. Pœonia peregrina flo.
coccineo.

II. ASARUM EUROPAEUM
Asarabacca

I. PAEONIA OFFICINALIS
Single common peony

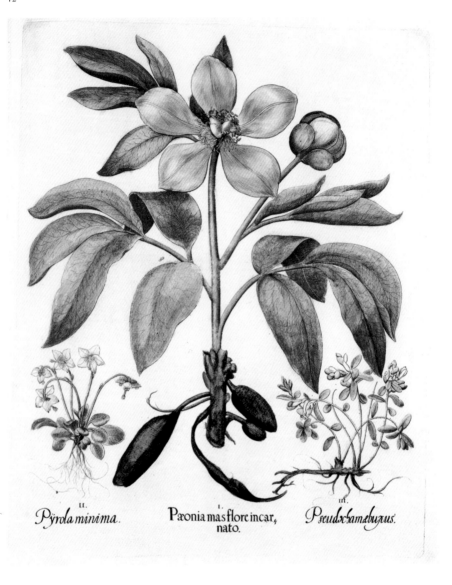

II.
Pyrola minima.

I.
Pæonia mas flore incar,
nato.

III.
Pseudochamæbuxus.

II. MONESES UNIFLORA
Wood nymph;
One-flowered wintergreen

I. PAEONIA MASCULA
Peony

III. POLYGALA CHAMAEBUXUS
Gand flower; Milkwort

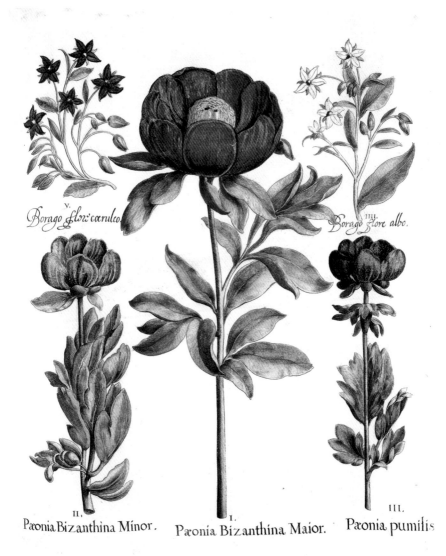

Borago flor cæruleo.

Borago flore albo.

II.
Pæonia Bizanthina Minor.

I.
Pæonia Bizanthina Maior.

III.
Pæonia pumilis

V. BORAGO OFFICINALIS
Tailwort; Borage

I. PAEONIA PEREGRINA
Common peony

IIII. BORAGO OFFICINALIS
Tailwort; Borage

II. PAEONIA PEREGRINA
Common peony

III. PAEONIA PEREGRINA
Common peony

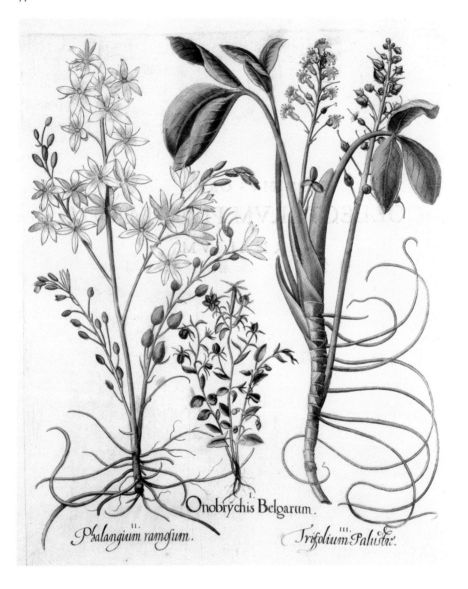

Onobrychis Belgarum.

Phalangium ramosum.

Trifolium Palustre.

II. ANTHERICUM RAMOSUM
Ramified antheric

I. LEGOUSIA SPECULUM-
VENERIS
Venus' looking glass

III. MENYANTHES TRIFOLIATA
*Bog bean; Buck bean;
Marsh trefoil*

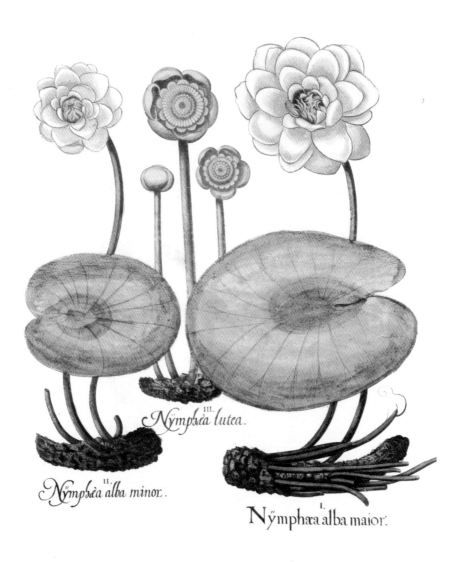

Nÿmphæa lutea.

Nÿmphæa alba minor.

Nÿmphæa alba maior.

II. NYMPHAEA ALBA
European white water lily

III. NUPHAR LUTEA
Yellow water lily; Brandy bottle

I. NYMPHAEA ALBA
European white water lily

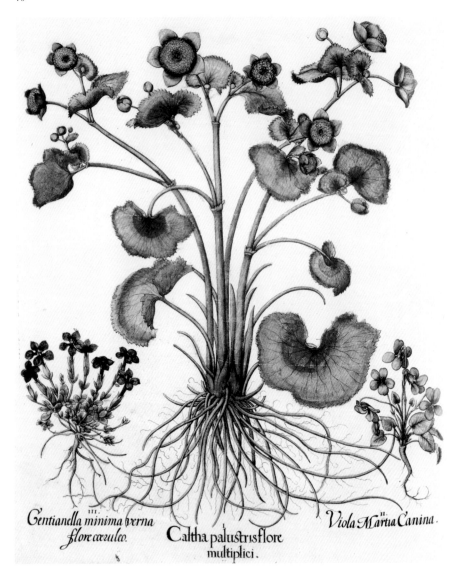

Gentianella minima verna
flore cœruleo.

ɪɪɪ.

Caltha palustrisflore
multiplici.

ɪ.

Viola Martia Canina.

ɪɪ.

III. GENTIANA VERNA
Spring gentian

I. CALTHA PALUSTRIS
Kingcup; Marsh marigold;
Meadow bright; May-blob

II. VIOLA CANINA
Dog violet; Heath violet

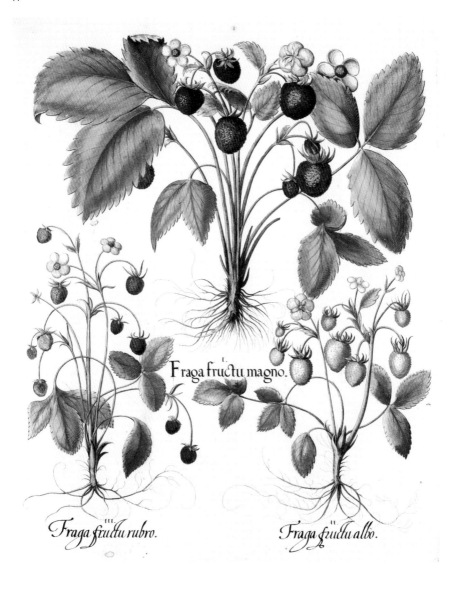

Fraga fructu magno.

Fraga fructu rubro.

Fraga fructu albo.

III. FRAGARIA SPEC.
Small-fruited strawberry

I. FRAGARIA SPEC.
Large-fruited Strawberry

II. FRAGARIA SPEC.
White-fruited strawberry

78

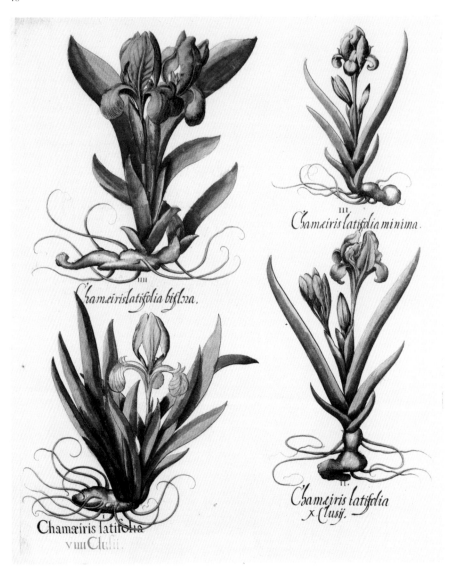

Chamæiris latifolia minima.

Chamæiris latifolia biflora.

Chamæiris latifolia
x Clusij.

Chamæiris latifolia
v iu Clusii.

IIII. IRIS PUMILA
Blue dwarf bearded iris

III. IRIS PUMILA
Bright yellow dwarf bearded iris

I. IRIS PUMILA
Dwarf-bearded iris with multi-coloured flowers

II. IRIS PUMILA
Dark red dwarf bearded iris

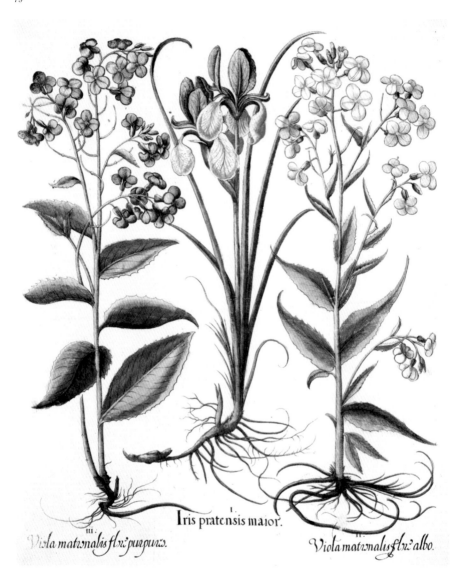

III.
Viola matronalis flre purpur̃.

I.
Iris pratensis maior.

II.
Viola matronalis flre albo.

III. HESPERIS MATRONALIS
Damask violet; Dame's violet;
Sweet rocket

I. IRIS SIBIRICA
Siberian iris

II. HESPERIS MATRONALIS
Damask violet; Dame's violet;
Sweet rocket

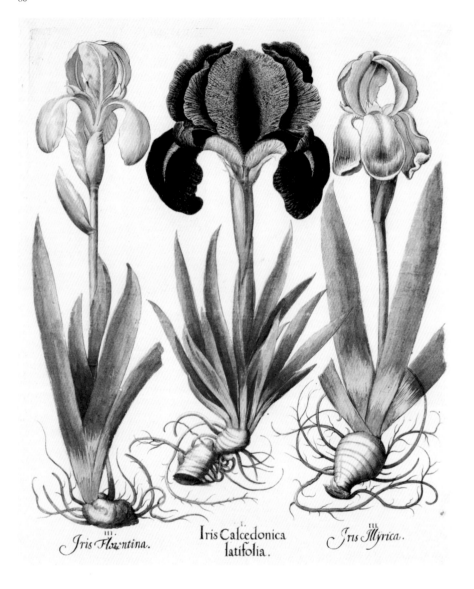

Iris Florentina.

Iris Calcedonica
latifolia.

Iris Illyrica.

II. IRIS FLORENTINA
Orris root

I. IRIS SPEC.
Iris

III. IRIS PALLIDA
Dalmatian iris

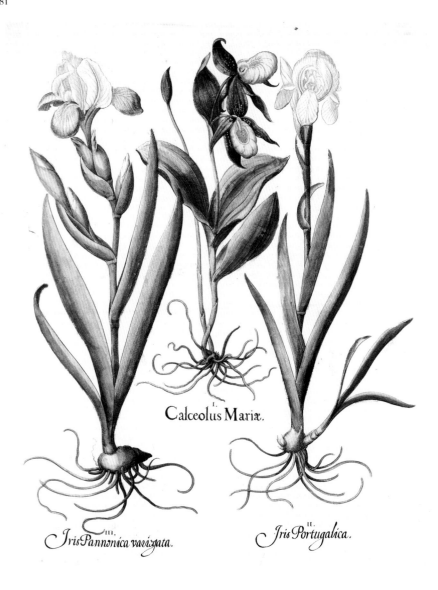

Calceolus Mariæ.

Iris Pannonica variegata.

Iris Portugalica.

III. IRIS SPEC.
Variegated iris
with multi-coloured flowers

I. CYPRIPEDIUM CALCEOLUS
Lady's slipper orchid

II. IRIS SPEC.
Iris

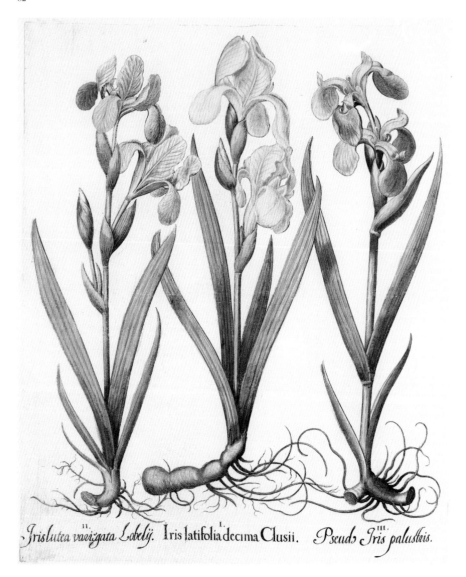

Iris lutea variegata Lobelij. II. *Iris latifolia decima Clusii.* I. *Pseud Iris palustris.* III.

II. IRIS VARIEGATA I. IRIS PALLIDA III. IRIS PSEUDOACORUS

Variegated iris *Dalmatian iris* *Yellow flag*

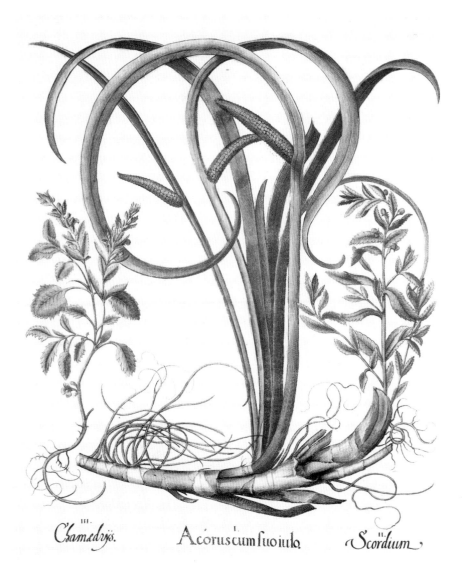

Chamædrys. · *Acoruscum suo iula* · *Scordium*

III. TEUCRIUM CHAMAEDRYS
Wall germander

I. ACORUS CALAMUS
Sweet flag; Sweet calamus;
Myrtle flag;
Calamus; Flagroot

II. TEUCRIUM SCORDIUM
Water germander

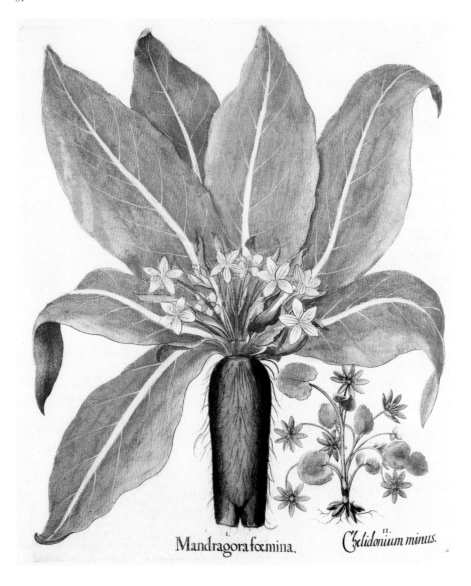

Mandragora fœmina. Chelidonium minus.

I. MANDRAGORA AUTUMNALIS
Autumn mandrake

II. RANUNCULUS FICARIA
Lesser celandine; Pilewort

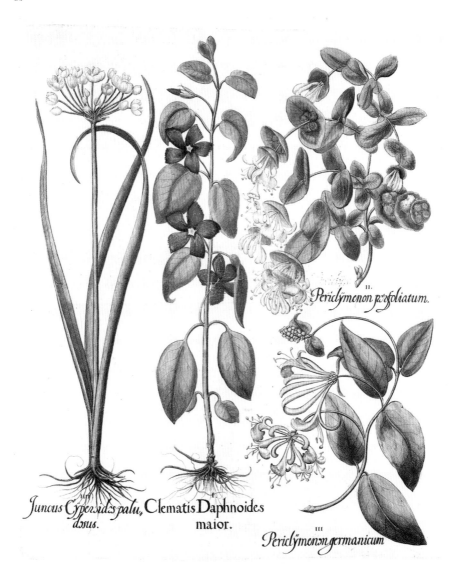

Juncus Cyperoides palu, dous. Clematis Daphnoides maior.

Periclÿmenon perfoliatum. II.

Periclÿmenon germanicum III.

IIII. BUTOMUS UMBELLATUS
Flowering rush; Water gladiolus;
Grassy rush

I. VINCA MAJOR
Greater periwinkle

II. LONICERA CAPRIFOLIUM
Italian woodbine;
Italian honeysuckle

III. LONICERA PERICLYMENUM
Woodbine; Honeysuckle

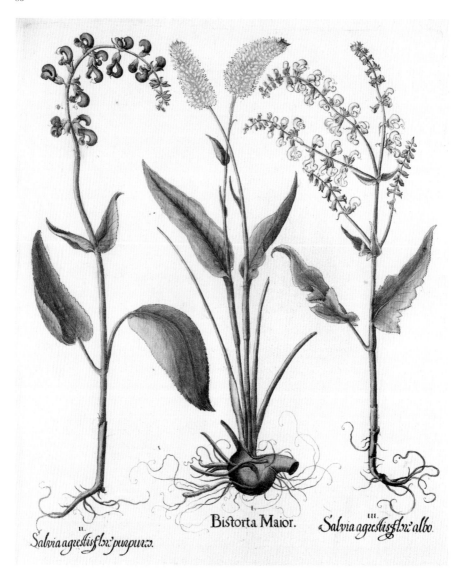

II. *Salvia agrestis flo: purpur:o.*

Bistorta Maior.

III. *Salvia agrestis flo: albo.*

II. SALVIA PRATENSIS
Blue meadow clary

I. POLYGONUM BISTORTA
Bistort; Snakeweed; Easter ledges

III. SALVIA PRATENSIS
White meadow clary

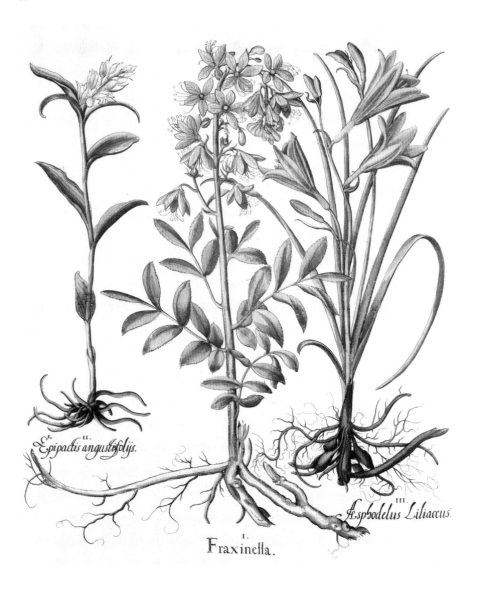

Epipactis angustifolijs.

II.

Fraxinella.

I.

Asphodelus Liliaceus.

III.

II. CEPHALANTHERA
DAMASONIUM
White helleborine

I. DICTAMNUS ALBUS
Dittany; Burning bush

III. HEMEROCALLIS
LILIOASPHODELUS
Yellow day lily

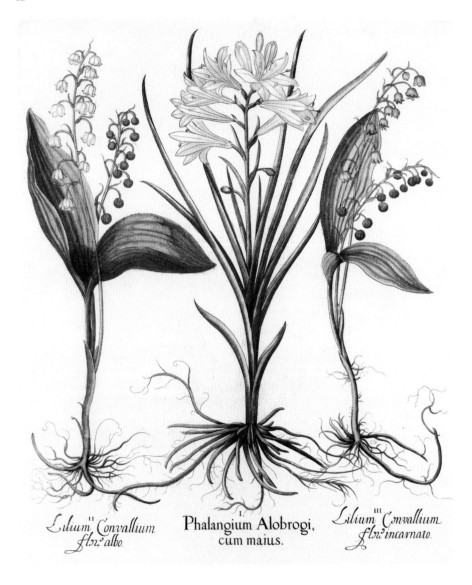

Lilium II *Convallium fl.* albo.

Phalangium Alobrogi, cum maius.

Lilium III *Convallium fl.* incarnato.

II. CONVALLARIA MAJALIS
Milk blue lily of the valley

I. PARADISEA LILIASTRUM
St Bruno's lily; Paradise lily

III. CONVALLARIA MAJALIS
Pink lily of the valley

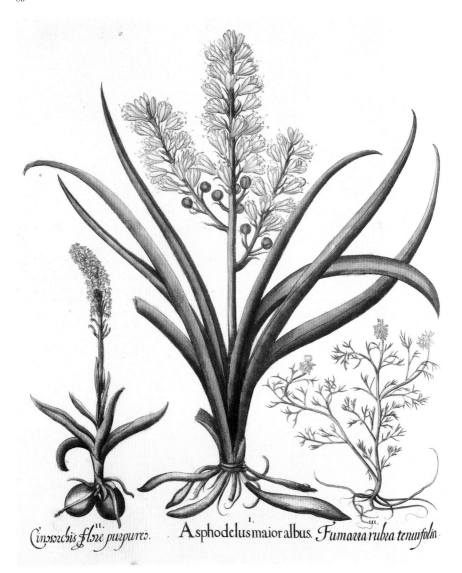

Cinxxxchis flore purpures. Asphodelus maior albus. Fumaria rubra tenuifolia.

II. ORCHIS USTULATA
Burnt orchid

I. ASPHODELUS RAMOSUS
Asphodel

III. FUMARIA SPICATA
Fumitory

Dorea Narbonenſium.

Lilium fatuum.

II. SENECIO DORIA
Groundsel

I. HEMEROCALLIS FULVA
Red-yellow day lily

Asparagus domesticus. Thyrfus Asparagi.

I. ASPARAGUS OFFICINALIS
Asparagus with flowers and fruits

II. ASPARAGUS OFFICINALIS
Spears of asparagus

PLANTARVM
HORTI EYSTÆT.
TENSIS.
Claſſis Æſtiva.

Nerion flore rubro. Fructus Neij.

I. NERIUM OLEANDER
Rose bay; Oleander

II. NERIUM OLEANDER
Rose bay; Oleander (in fruit)

94

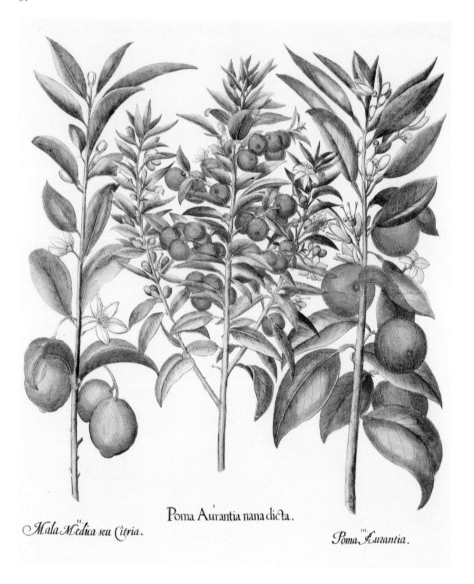

Mala Medica seu Citria.

Poma Aurantia nana dicta.

Poma Aurantia.

II. CITRUS MEDICA
Citron

I. CITRUS AURANTIUM
Seville orange; Bitter orange;
Sour orange; Bigarade

III. CITRUS SINENSIS
Common or sweet orange

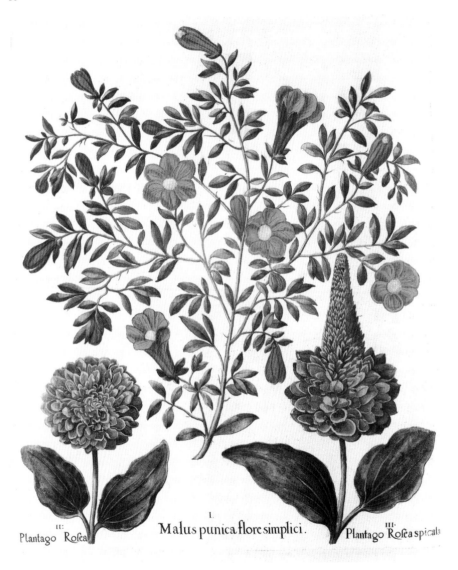

II:
Plantago Rosea

I.
Malus punica flore simplici.

III:
Plantago Rosea spicata

II. PLANTAGO MAJOR
*Common plantain; White-man's
foot; Cart-track plant*

I. PUNICA GRANATUM
Pomegranate

III. PLANTAGO MAJOR
*Common plantain; White-man's
foot; Cart-track plant*

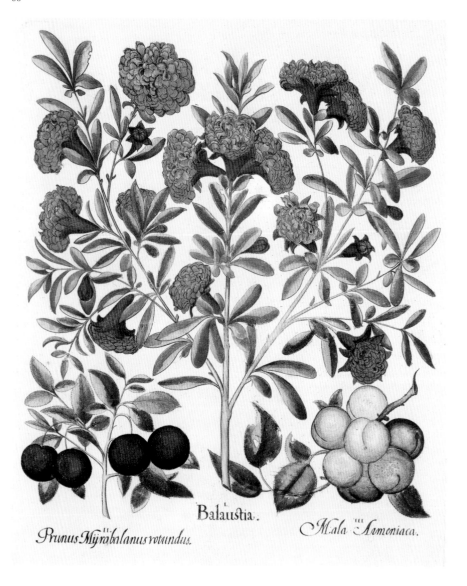

Prunus Myrobalanus rotundus.

Balaustia.

Mala Armeniaca.

II. PRUNUS CERASIFERA
Cherry plum; Myrobalan

I. PUNICA GRANATUM
Pomegranate with fruits

III. PRUNUS ARMENIACA
Apricot

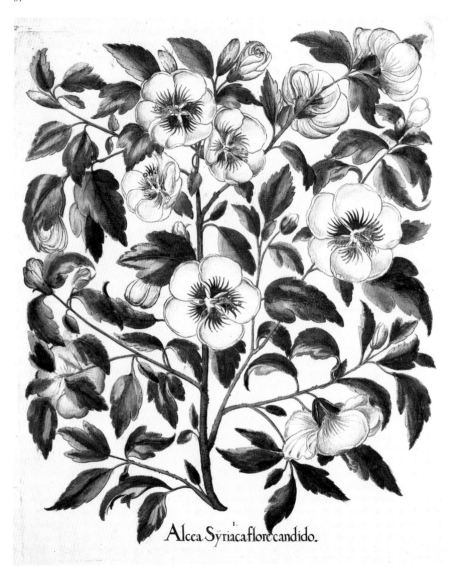

Alcea Sÿriaca flore candido.

I. HIBISCUS SYRIACUS
White-flowering mallow; Rose mallow; Giant mallow

98

Herba Paris.

Digitalis flore luteo.

Digitalis flox: incarnato.

III. DIGITALIS GRANDIFLORA
Large foxglove

I. PARIS QUADRIFOLIA
Herb Paris

II. DIGITALIS PURPUREA
Red foxglove

III.
Hieracium peregrinum

Digitalis flore rubro.

Digitalis flore albo.

II. DIGITALIS PURPUREA
Red foxglove

III. HIERACIUM AURANTIACUM
Fox and cubs; Orange hawkweed

I. DIGITALIS PURPUREA
White foxglove

III.
Medium flore cœruleo.

I
Valeriana Rubra.

II.
Medium flore albo.

III. CAMPANULA MEDIUM
Blue canterbury bells;
Cup and saucer

I. CENTRANTHUS RUBER
Red valerian; Jupiter's beard;
Fox's brush

II. CAMPANULA MEDIUM
White canterbury bells;
Cup and saucer

Medium flore argenteo.

Lychnis Sylvestris.

Lychnis Sylvestris flore albo.

II. SILENE VULGARIS
Bladder campion; Cathfly

I. CAMPANULA MEDIUM
Canterbury bells; Cup and saucer

III. SILENE NUTANS
Campion; Catchfly

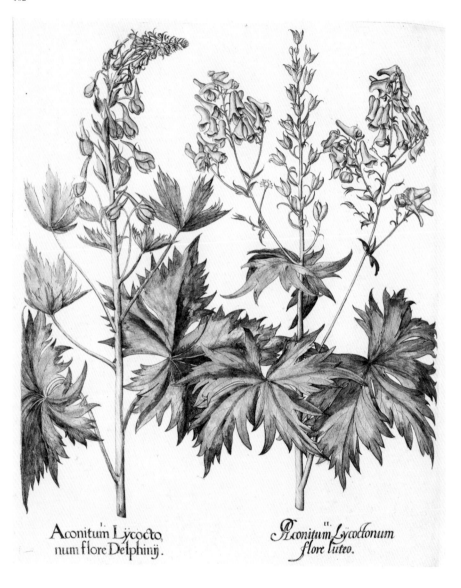

I. *Aconitum Lycocto, num flore Delphinij.*

II. *Aconitum Lycoctonum flore luteo.*

I. DELPHINIUM ELATUM
Bee larkspur

II. ACONITUM VULPARIA
Wolfsbane; Badger's bane; Monkshood

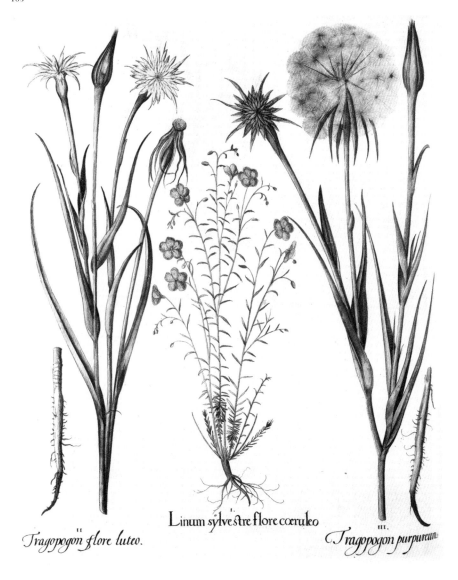

Tragopogon flore luteo.

Linum sylvestre flore cœruleo

Tragopogon purpureum

II. TRAGOPOGON DUBIUS
Goat's beard

I. LINUM PERENNE
Perennial flax

III. TRAGOPOGON
PORRIFOLIUS
Salsify vegetable oyster;
Oyster plant

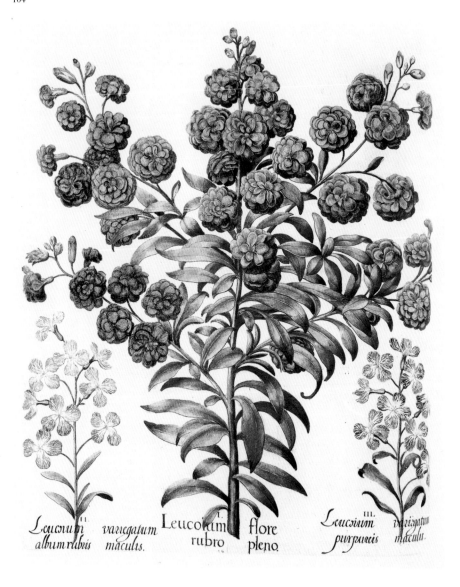

Leucoium *variegatum*
album rubris *maculis.*

Leucoium *flore*
rubro *pleno.*

Leucoium *variegatum*
purpureis *maculis.*

II. MATTHIOLA INCANA
Gillyflower; Stock

I. MATTHIOLA INCANA
Double pink gillyflower; Stock

III. MATTHIOLA INCANA
Gillyflower; Stock

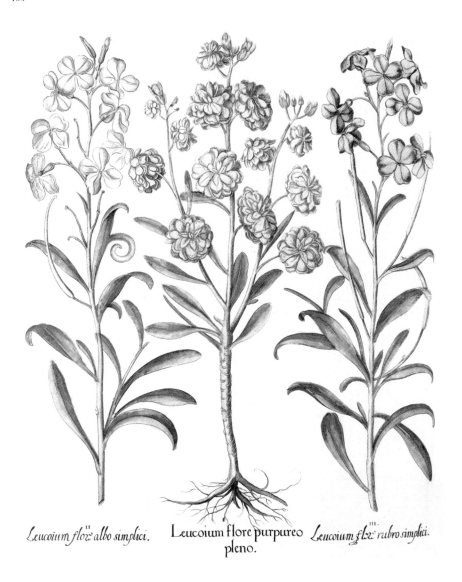

Leucoium flor̄ albo simplici. *Leucoium flore purpureo pleno.* *Leucoium flr̄ rubro simplici.*

II. MATTHIOLA INCANA
Single white gillyflower; Stock

I. MATTHIOLA INCANA
Double gillyflower; Stock

III. MATTHIOLA INCANA
Single purple gillyflower; Stock

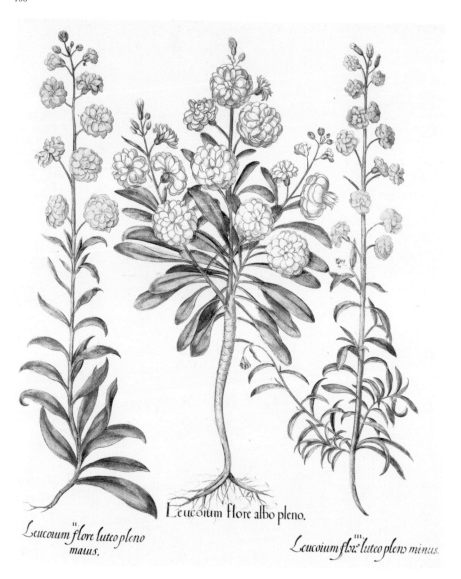

Leucoium flore luteo pleno maius.

Leucoium flore albo pleno.

Leucoium flor. luteo pleno minus.

II. CHEIRANTHUS CHEIRI
Double wallflower

I. MATTHIOLA INCANA
Single white gillyflower;
Stock

III. CHEIRANTHUS CHEIRI
Double wallflower

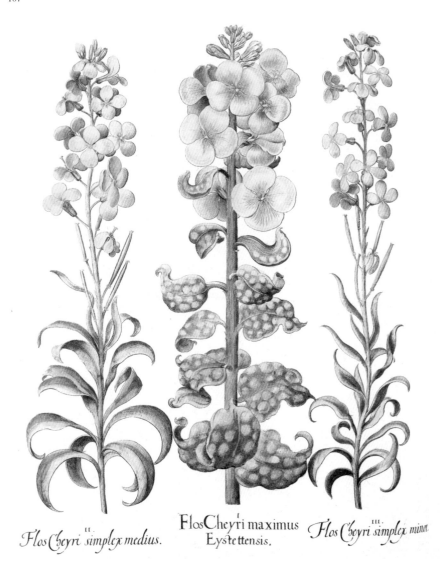

Flos Cheyri simplex medius.

Flos Cheyri maximus
Eystettensis.

Flos Cheyri simplex minor.

II. CHEIRANTHUS CHEIRI
Single wallflower

I. CHEIRANTHUS CHEIRI
"Wallflower of Eichstätt"

III. CHEIRANTHUS CHEIRI
Single wallflower

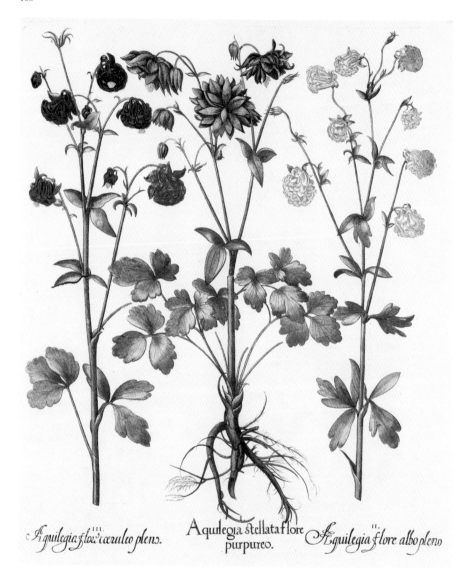

Aquilegia flore cæruleo pleno.

Aquilegia stellata flore purpureo.

Aquilegia flore albo pleno

III. AQUILEGIA VULGARIS
Double blue columbine;
Granny's bonnets

I. AQUILEGIA VULGARIS
Columbine with starlike,
double, deep violet flowers;
Granny's bonnets

II. AQUILEGIA VULGARIS
Double white columbine;
Granny's bonnets

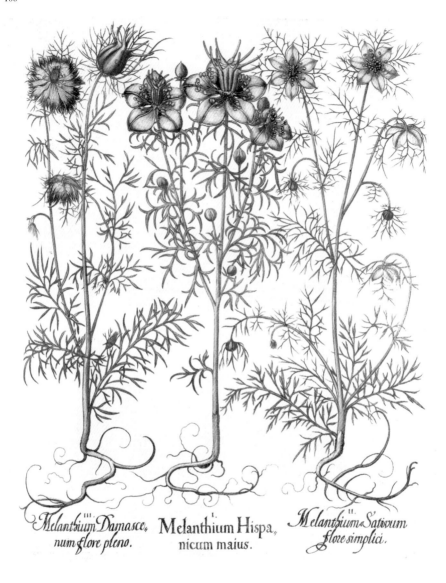

Melanthium Damasce,
num flore pleno.

Melanthium Hispa,
nicum maius.

Melanthium Satiwum
flore simplici.

III. NIGELLA DAMASCENA
Love-in-a-mist; Ragged lady

I. NIGELLA HISPANICA
Fennel-flower

II. NIGELLA DAMASCENA
Love-in-a-mist; Ragged lady

110

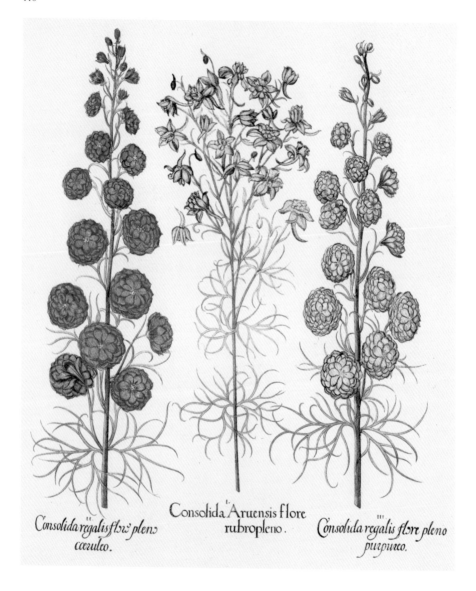

Consolida regalis flor plens
cœruleo.

Consolida Aruensis flore
rubropleno.

Consolida regalis flore pleno
purpureo.

II. CONSOLIDA AJACIS
Double deep blue larkspur

I. CONSOLIDA REGALIS
Double pink larkspur

III. CONSOLIDA AJACIS
Double purple larkspur

Leucoium fruticosum folio viri,
di flore albo odorato Camerarij.

Leucoium Sylvestre medium
flore parvo pallidize.

Leucoium Melancholico colore

II. ERYSIMUM SPEC.
Wallflower

I. MATTHIOLA INCANA
Gillyflower; Stock

III. MATTHIOLA INCANA
Gillyflower; Stock

I. LILIUM MARTAGON

Inflorescence of martagon or turk's cap lily

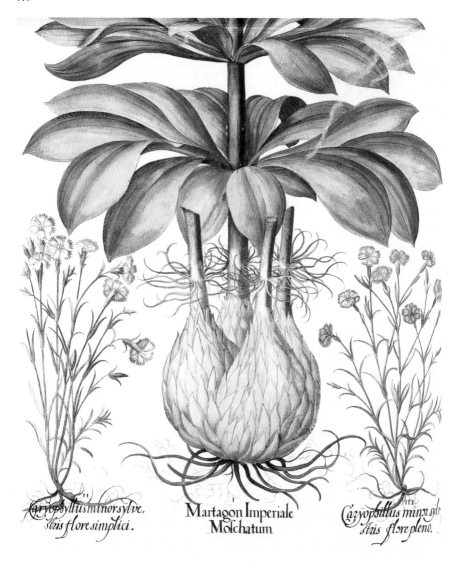

Caryophyllus minor sylve-
stris flore simplici.

Martagon Imperiale
Moschatum

Caryophillus minn syl-
stris flore pleno.

II. DIANTHUS SPEC.
Carnation; Pink

I. LILIUM MARTAGON
Bulb and basal leaves
of martagon or turk's cap lily

III. DIANTHUS SPEC.
Carnation; Pink

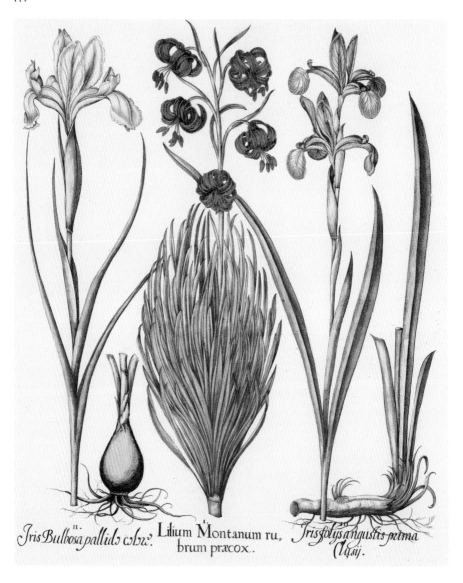

Iris Bulbosa pallids colxc. Lilium Montanum ru, *Irisfolys angustis prima*
brum præcox. *Clsij.*

II. IRIS XIPHIUM I. LILIUM POMPONIUM III. IRIS SIBIRICA

Spanish iris *Lily* *Siberian iris*

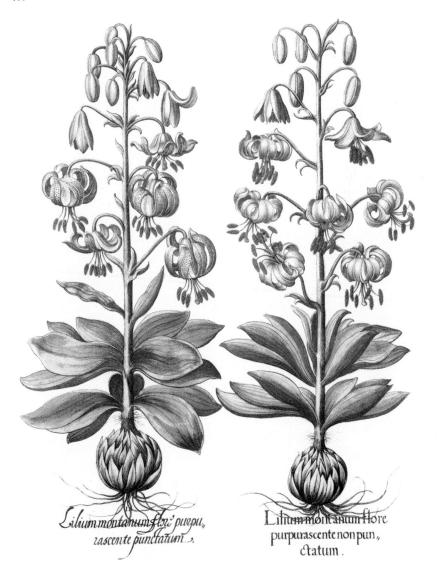

*Lilium montanum flore purpu-
rascente punctatum.*

*Lilium montanum flore
purpurascente non pun-
ctatum.*

II. LILIUM MARTAGON
Martagon lily; Turk's cap lily

I. LILIUM MARTAGON
Martagon lily; Turk's cap lily

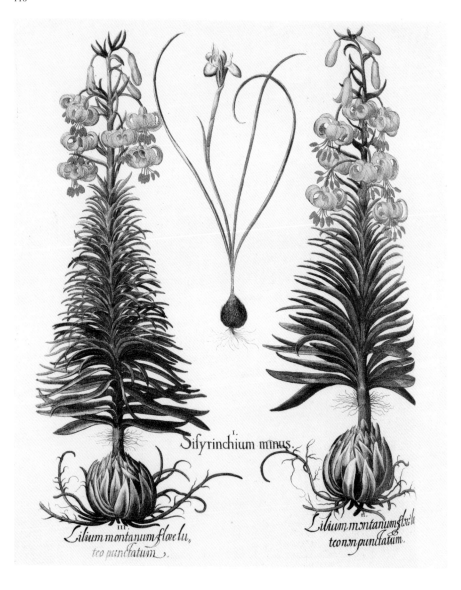

III. LILIUM PYRENAICUM
Yellow spotted turk's cap lily

I. GYNANDRIRIS SISYRINCHIUM
Iris

II. LILIUM PYRENAICUM
Yellow turk's cap lily

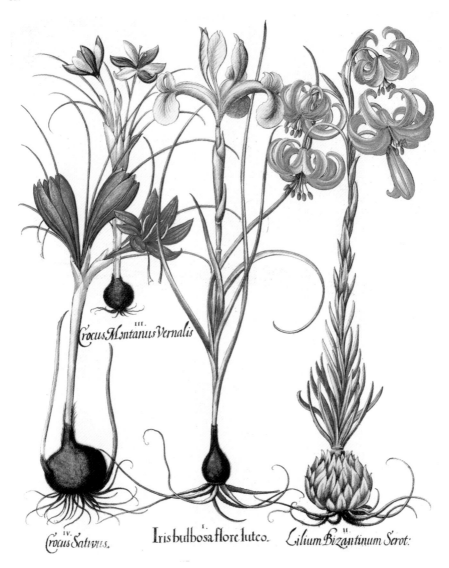

Crocus Montanus Vernalis

Crocus Sativus. *Iris bulbosa flore luteo.* *Lilium Bizantinum Serot:*

III. CROCUS SPEC.
Dutch crocus

IIII. CROCUS SATIVUS
Saffron crocus

I. IRIS XIPHIUM
Spanish iris

II. LILIUM CHALCEDONICUM
Scarlet turk's cap lily;
Red martagon of Constantinople

Dracontium maius.

1. DRACUNCULUS VULGARIS
Dragon arum (with rhizome)

IIII.
Dentaria radice coral-
lide.

III.
Nidus Avis.

II.
Cynosorchis femina.

I.
Orchis latifolia.

IIII. CORALLORHIZA TRIFIDA
Coralroot orchid

I. ORCHIS PURPUREA
Lady orchid

II. ORCHIS CORIOPHORA
Bug orchid

III. NEOTTIA NIDUS-AVIS
Bird's nest orchid

Gladiolus Narbonensis flxe incarnato.

Victorialis Rotunda

Iris Bulbosa flore diluto cœruleo.

Gladiolus Narbonensium fls, re purpureo.

II. GLADIOLUS PALUSTRIS
Marsh gladiolus

I. IRIS XIPHIOIDES
English iris

III. GLADIOLUS COMMUNIS
Common gladiolus
with dark flowers

IIII. GLADIOLUS COMMUNIS
Common gladiolus
with violet flowers

Iris bulbosa mixta. Moly latifolium. *Iris bulbosa variegata.*

III. IRIS XIPHIUM I. ALLIUM AMPELOPRASUM II. IRIS XIPHIUM
Spanish iris *Wild leek; Levant garlic; Kurrat* *Spanish iris*

Flos Solis maior.

1. HELIANTHUS ANNUUS
Common sunflower

Flos Solis prolifer.

I. HELIANTHUS × MULTIFLORUS
Sunflower

Pyrethrum Officinarum.

Cotyledon minus.

II. ANACYCLUS PYRETHRUM
Mount Atlas daisy

I. SAXIFRAGA COTYLEDON
Great Alpine rockfoil; Greater evergreen saxifrage

I.
Pyrola.

III.
Eranthemumflor. flammex.

II.
Eranthemumflor. rubr.

III. ADONIS FLAMMEA
Flame-coloured pheasant's eye

I. PYROLA MINOR
Lesser wintergreen

II. ADONIS ANNUA
Pheasant's eye

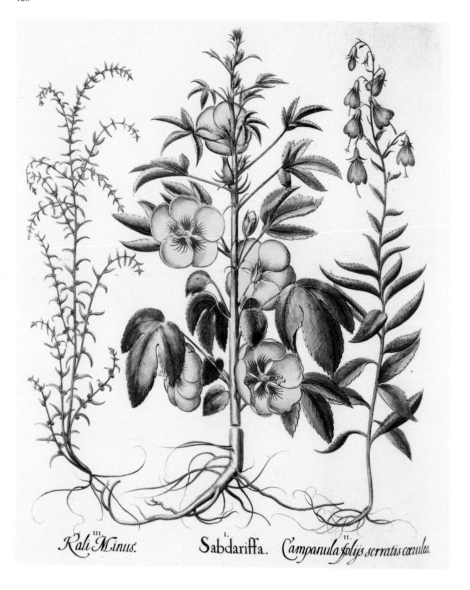

Kali Minus. *Sabdariffa.* *Campanula folijs serratis cœrulea.*

III. SALSOLA KALI
Prickly saltwort

I. HIBISCUS SABDARIFFA
Roselle; Jamaica sorrel; Red sorrel

II. CAMPANULA LATIFOLIA
Bellflower

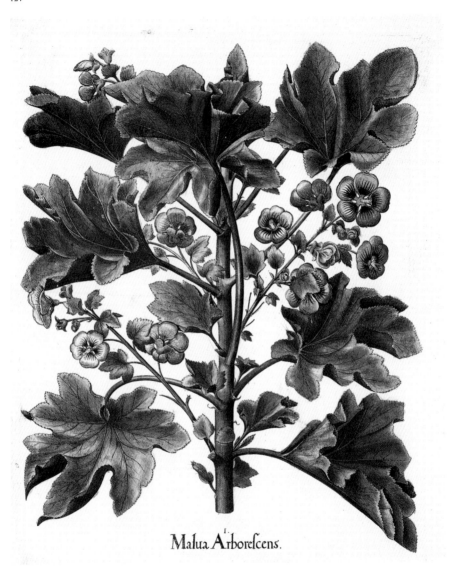

Malua Arborescens.

1. LAVATERA ARBOREA
Tree mallow

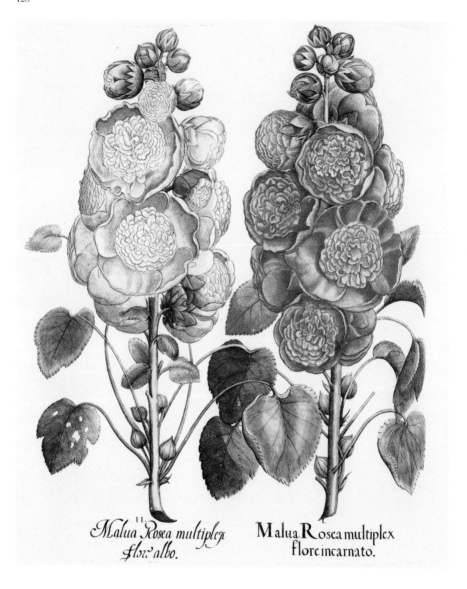

Malua Rosea multiplex flor. albo.

Malua Rosea multiplex flore incarnato.

II. ALCEA ROSEA
Double blue hollyhock

I. ALCEA ROSEA
Double pink hollyhock

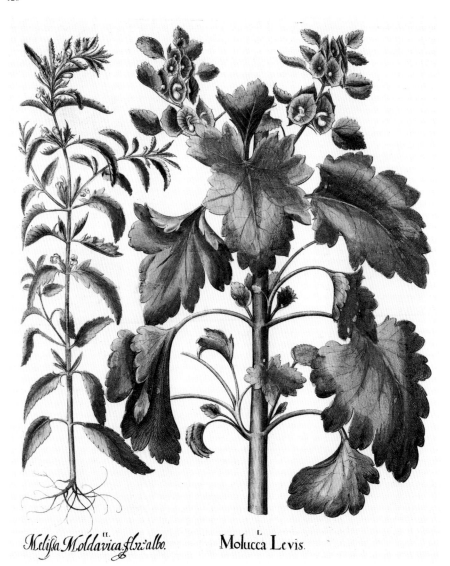

Melissa Moldavica flor. albo. *Molucca Levis.*

II. DRACOCEPHALUM MOLDAVICA
Dragon's head

I. MOLUCCELLA LAEVIS
Bells of Ireland; Shell-flower

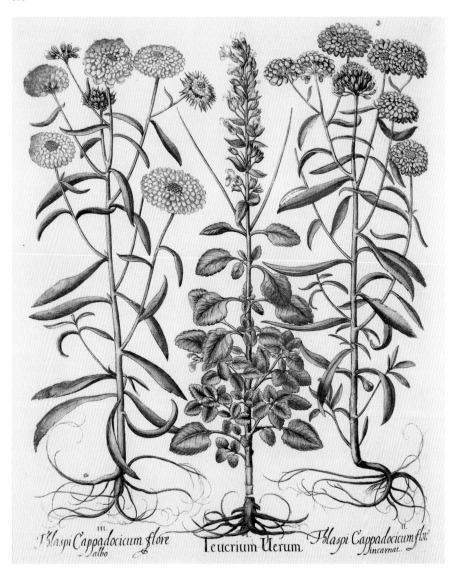

III. IBERIS UMBELLATA
Common candytuft

I. TEUCRIUM SCORODONIA
Wood sage;
Sage-leaved germander

II. IBERIS UMBELLATA
Common candytuft

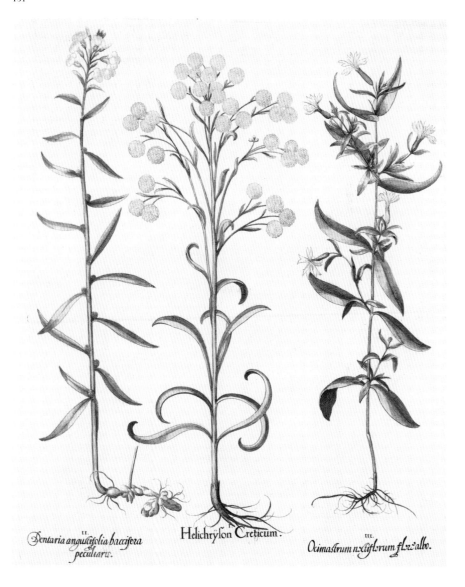

Dentaria angustifolia baccifera peculiaris. Helichryſon Creticum. *Ocimastrum nxliflorum flx:albo.*

II. DENTARIA BULBIFERA
Coral root bittercress; Coralwort

I. HELICHRYSUM ORIENTALE
Everlasting flower

III. SILENE NOCTIFLORA
Night-flowering catchfly

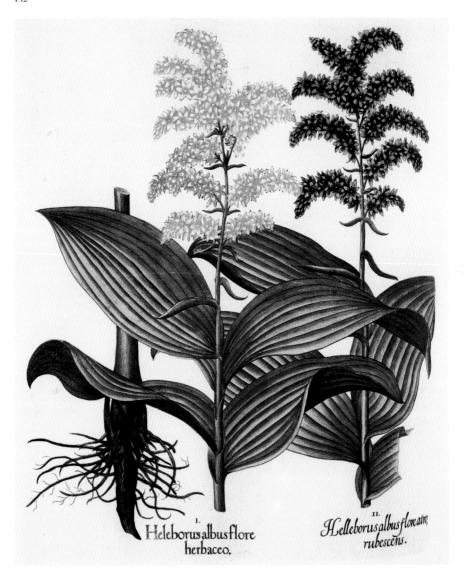

I.
Heleborus albus flore
herbaceo.

II.
Helleborus albus flore atro
rubescens.

I. VERATRUM ALBUM
False hellebore; White hellebore

II. VERATRUM NIGRUM
Black hellebore

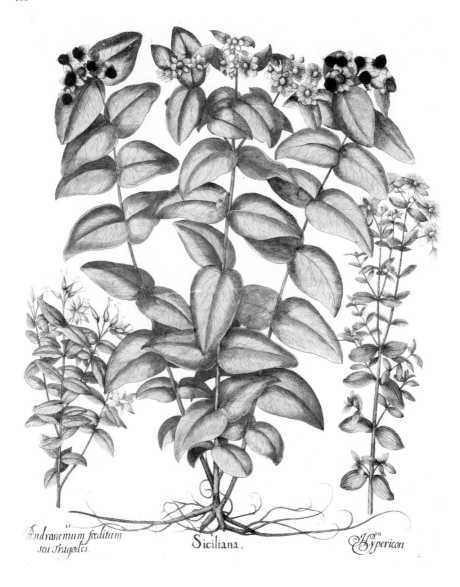

Androsæmum fœditum seu Tragodes.

Siciliana.

Hypericon

II. HYPERICUM HIRCINUM
St John's wort

I. HYPERICUM ANDROSAEMUM
Tutsan

III. HYPERICUM MACULATUM
St John's wort

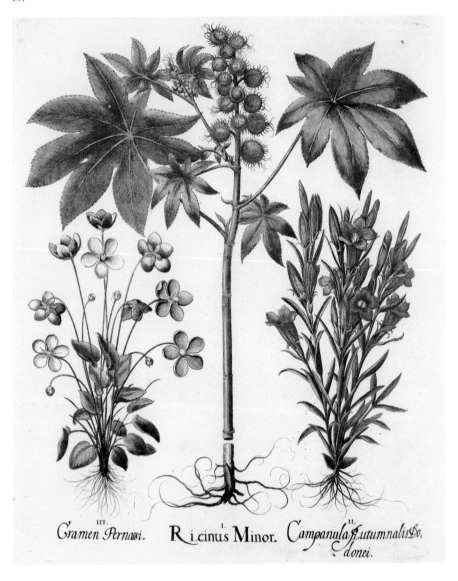

III.
Gramen Pernassi.

I.
Ricinus Minor.

II.
Campanula Autumnalis Do-
donei.

III. PARNASSIA PALUSTRIS
Grass of Parnassus

I. RICINUS COMMUNIS
Castor oil plant; Palma Christi;
Castor bean plant

II. GENTIANA PNEUMONANTHE
Marsh gentian; Calathian violet

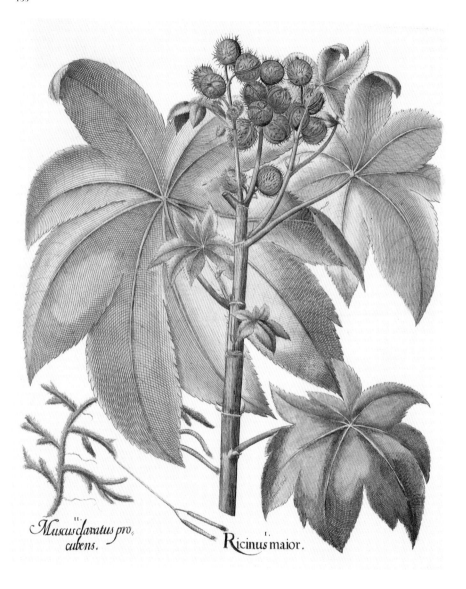

II.
Muscus clavatus pro-
cubens.

I.
Ricinus maior.

II. LYCOPODIUM CLAVATUM
Ground pine; Running pine

I. RICINUS COMMUNIS
Castor oil plant; Palma Christi;
Castor bean plant

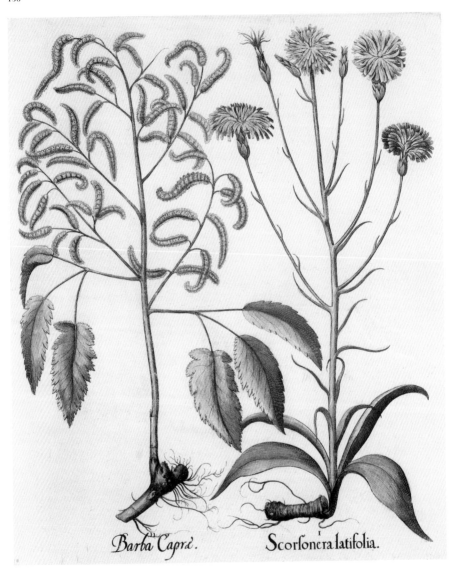

Barba Capræ.

Scorſonera latifolia.

II. ARUNCUS DIOICUS
Goat's beard

I. SCORZONERA HISPANICA
Common viper's grass

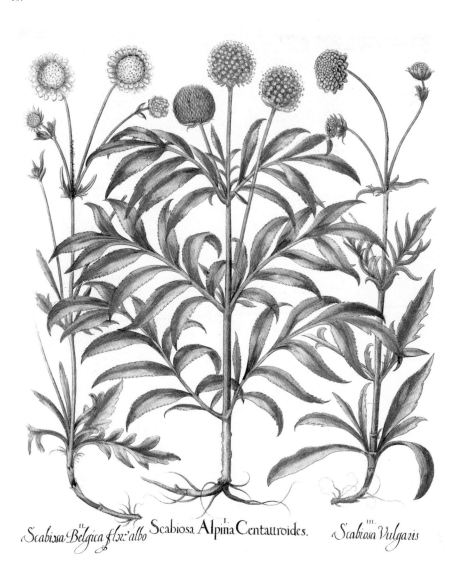

Scabiosa Belgica flor: albo Scabiosa Alpina Centauroides. *Scabiosa Vulgaris*

II. SCABIOSA STELLATA
Pincushion flower; Scabious

I. CEPHALARIA ALPINA
Alpine scabious

III. KNAUTIA ARVENSIS
Blue buttons; Field scabious

Scabiosa Indica flœ dilute
rubro

Scabiosa Indica flore sa
turate rubro.

Scabissa tenuifolia flore
cinereo.

II. SCABIOSA ATROPURPUREA
Mournful widow; Sweet scabious;
Pincushion flower; Egyptian rose

I. SCABIOSA ATROPURPUREA
Mournful widow;
Double sweet scabious;
Pincushion flower; Egyptian rose

III. SCABIOSA COLUMBARIA
Small scabious

139

Valeriana Greca flore albo. *Valeriana maior.* *Valeriana Greca flore cœruleo.*

II. POLEMONIUM CAERULEUM
*Jacob's ladder; Greek valerian
with white flowers; Charity*

I. VALERIANA PHU
Valerian

III. POLEMONIUM CAERULEUM
*Jacob's ladder; Greek valerian
with mauve flowers; Charity*

II.

Ononis flore lutes variega.
ta, non spinosa.

Capparis Fabago.

II. ONONIS NATRIX
Restharrow

I. ZYGOPHYLLUM FABAGO
Syrian bean caper

Blattaria flōe luteo. II.

Blattaria flore albo. I.

Blattaria Plinij, Ver, III.
bascum nigrum.

II. VERBASCUM BLATTARIA
Moth mullein

I. VERBASCUM BLATTARIA
Moth mullein

III. VERBASCUM NIGRUM
Dark mullein

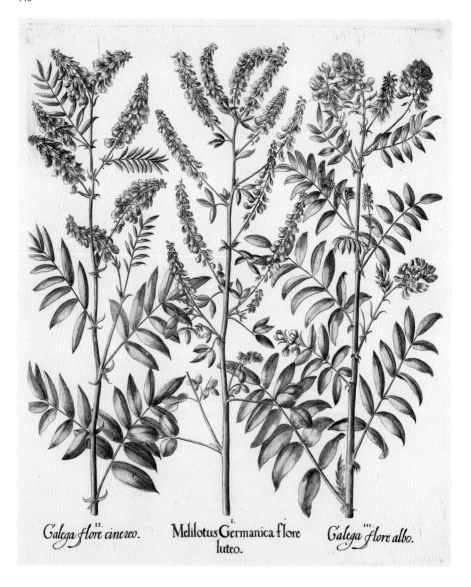

Galega flore cinereo. II.

Melilotus Germanica flore I.
luteo.

Galega flore albo. III.

II. GALEGA OFFICINALIS
Goat's rue

I. MELILOTUS OFFICINALIS
Yellow melilot; Ribbed melilot;
Yellow sweet clover

III. GALEGA OFFICINALIS
Goat's rue

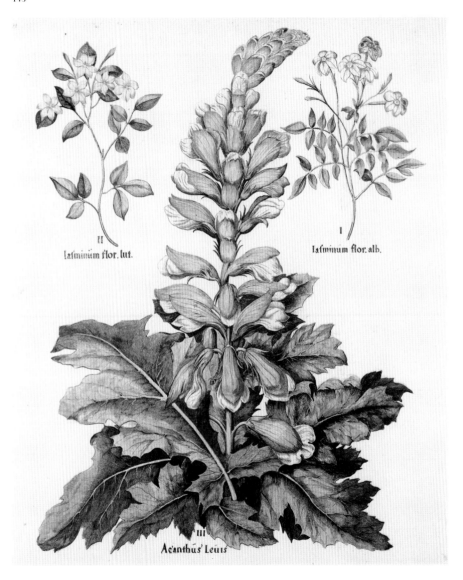

II
Iaſminũm flor. lut.

I
Iaſminum flor. alb.

III
Acanthús Leuıs

II. JASMINUM ODORATISSIMUM
OR JASMINUM FRUTICANS
Jasmine; Jessamine

III. ACANTHUS MOLLIS
Bear's breeches

I. JASMINUM GRANDIFLORUM
OR JASMINUM OFFICINALE
*Common jasmine; True jasmine;
Jessamine*

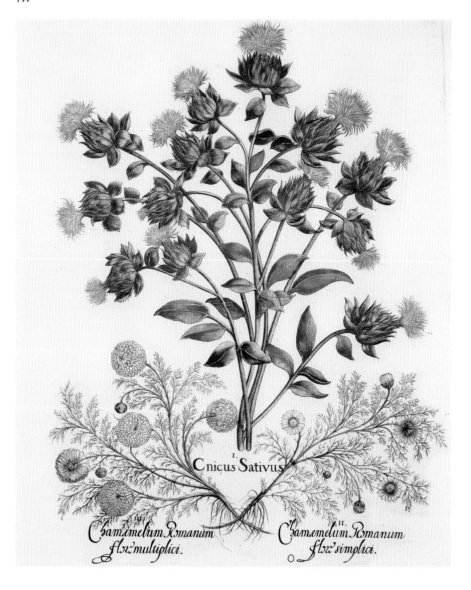

I.
Cnicus Sativus

III.
Chamæmelum Romanum
flor. multiplici.

II.
Chamæmelum Romanum
flor. simplici.

III. CHAMAEMELUM NOBILE
*Double chamomile; Roman
chamomile*

I. CARTHAMUS TINCTORIUS
Safflower; False saffron

II. CHAMAEMELUM NOBILE
Chamomile; Roman chamomile

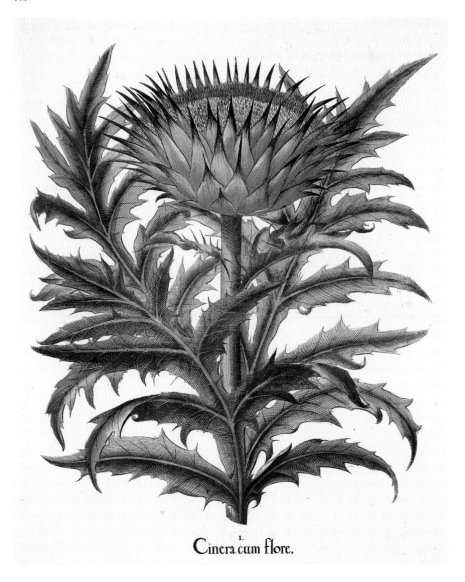

I.

Cinera cum flore.

1. CYNARA CARDUNCULUS
Cardoon

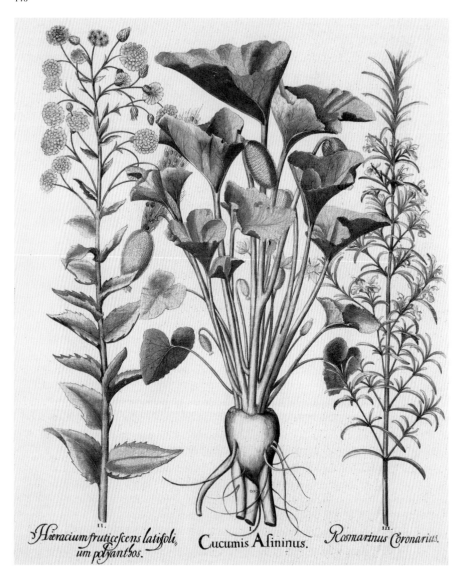

Hieracium fruticescens latifoli, um polyanthos.

Cucumis Asininus.

Rosmarinus Coronarius.

II. HIERACIUM INULOIDES OR
HIERACIUM VULGATUM
Common hawkweed

I. ECBALLIUM ELATERIUM
Squirting cucumber

III. ROSMARINUS OFFICINALIS
Rosemary

147

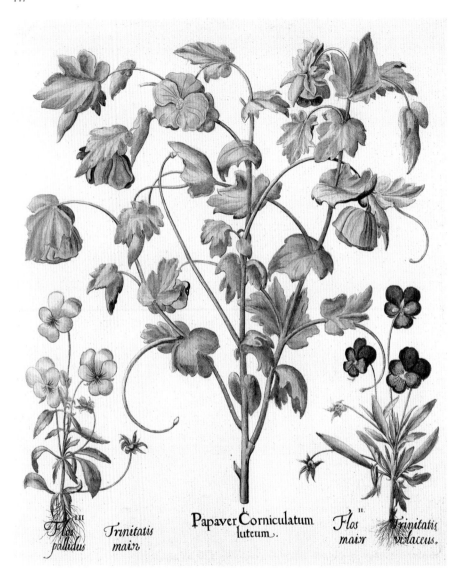

Flos
pallidus Trinitatis
 mair

Papaver Corniculatum
luteum.

Flos
mair Trinitatis
 violaceus.

III. VIOLA TRICOLOR
Wild pansy; Heart's-ease;
Love-in-idleness;
Jonny jump up; Pink of my John

I. GLAUCIUM FLAVUM
Yellow horned poppy

II. VIOLA TRICOLOR
Wild pansy; Heart's-ease;
Love-in-idleness;
Jonny jump up; Pink of my John

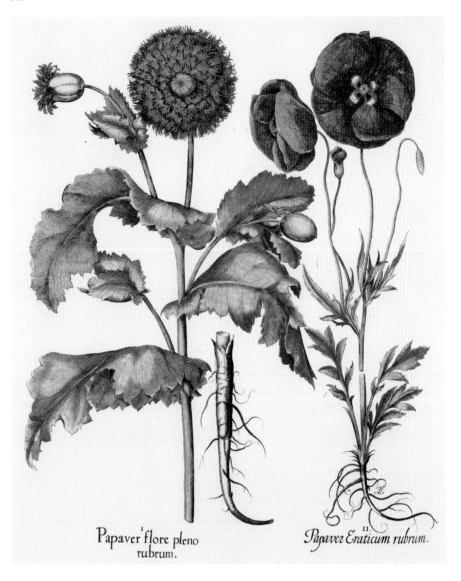

Papaver flore pleno
rubrum.

Papaver Eraticum rubrum.

I. PAPAVER SOMNIFERUM
Double opium poppy

II. PAPAVER RHOEAS
Corn poppy; Field poppy

149

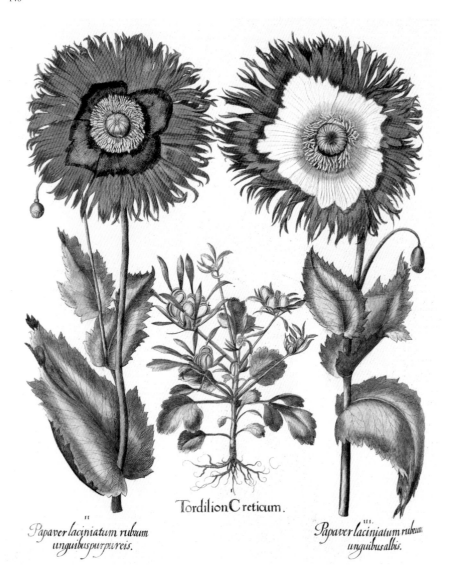

Papaver laciniatum rubrum
unguibus purpureis.

TordilionCreticum.

III.
Papaver laciniatum rubrum
unguibus albis.

II. PAPAVER SOMNIFERUM
Double opium poppy
with bi-coloured flowers

I. TORDYLIUM APULUM OR
TORDYLIUM OFFICINALE
Hartwort

III. PAPAVER SOMNIFERUM
Double opium poppy
with bi-coloured flowers

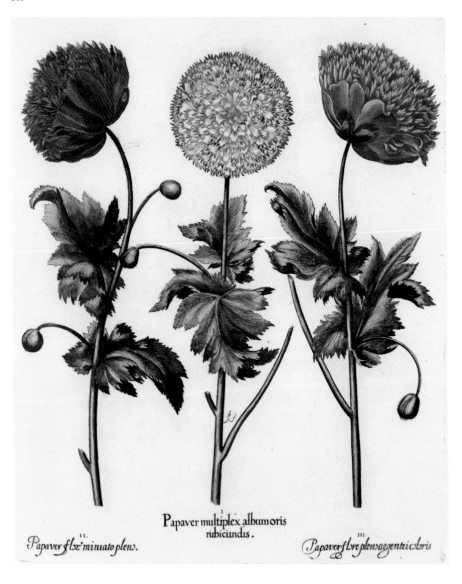

Papaver flx'miniato plens.

Papaver multiplex albumoris rubicundis.

Papaverflsreplensaegentricloris

II. PAPAVER SOMNIFERUM
Double opium poppy

I. PAPAVER SOMNIFERUM
Double opium poppy

III. PAPAVER SOMNIFERUM
Double opium poppy

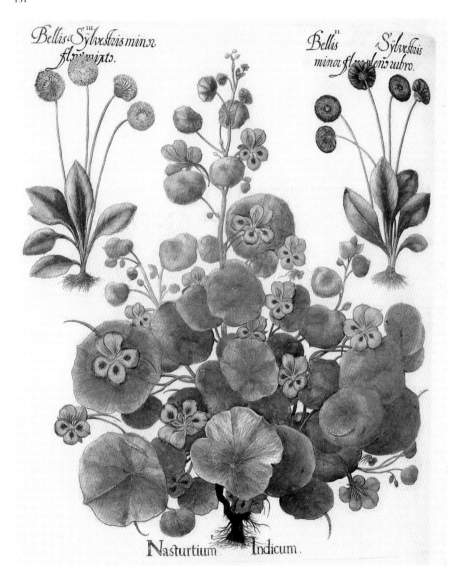

Bellis Sÿlvestris min̄r.̄ flo̅ro̅ miscts.

Bellis minor flore plens̄ rubro.

Nasturtium Indicum.

III. BELLIS SPEC.
Daisy

I. TROPAEOLUM MINUS
Nasturtium; Indian cress;
Canary bird vine;
Canary bird flower; Flame flower

II. BELLIS SPEC.
Daisy

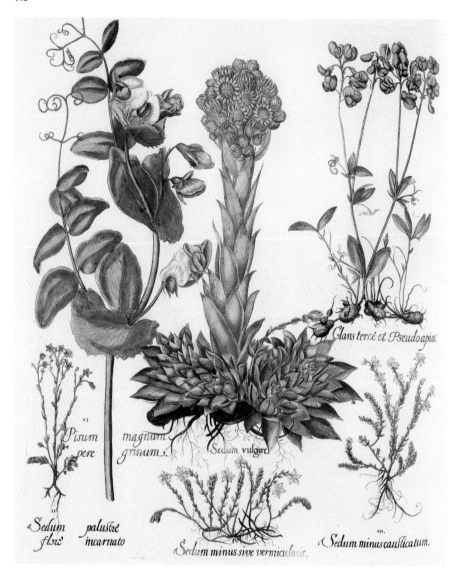

Clans terræ et Pseudoapios.

VI
Pisum *magnum*
pere *grinum.*

Sedum vulgare.

Sedum *palustre*
flos *incarnato*

Sedum minus sive vermiculares.

Sedum minus causticatum.

VI. PISUM SATIVUM
Garden pea

I. SEMPERVIVUM TECTORUM
Common houseleek

V. LATHYRUS TUBEROSUS
Earth chestnut; Tuberous pea;
Fyfield pea; Earth-nut pea;
Dutch mice; Tuberous vetch

II. SEDUM PILOSUM
Stonecrop

IIII. SEDUM SEXANGULARE
Stonecrop

III. SEDUM ACRE
Stonecrop; Wall pepper

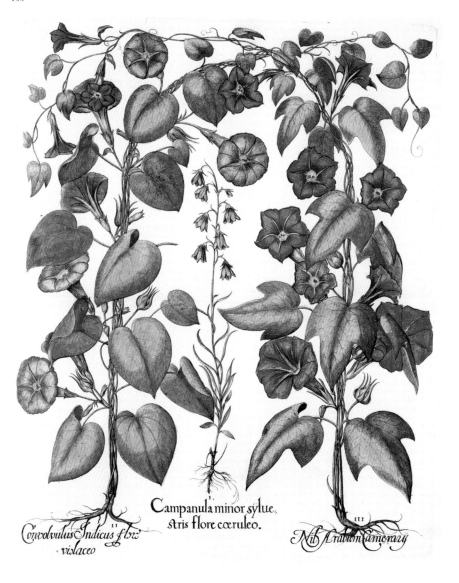

Campanula minor sylue,
stris flore cœruleo.

Convolvulus Indicus flor
vislaceo

Nil Arabum Camerary

II. PHARBITIS PURPUREA
Common morning glory

I. CAMPANULA ROTUNDIFOLIA
Bluebell; Harebell

III. PHARBITIS NIL
Morning glory

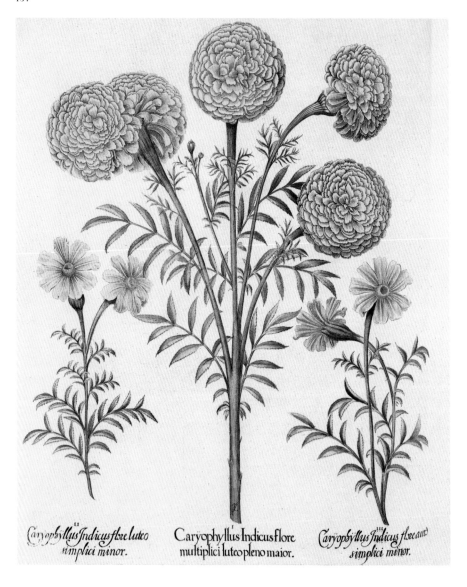

Caryophyllus Indicus flore luteo simplici minor.

Caryophyllus Indicus flore multiplici luteo pleno maior.

Caryophyllus Indicus flore auõ simplici minor.

II. TAGETES PATULA
French marigold

I. TAGETES ERECTA
African marigold

III. TAGETES PATULA
French marigold

155

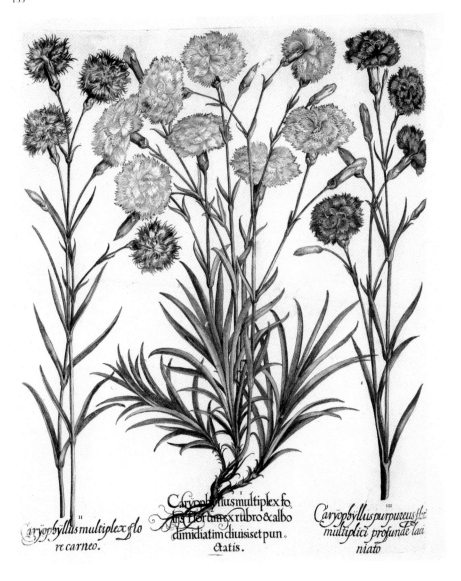

II. DIANTHUS PLUMARIUS
Cottage pink

I. DIANTHUS CARYOPHYLLUS
Wild carnation

III. DIANTHUS CARYOPHYLLUS
Wild carnation

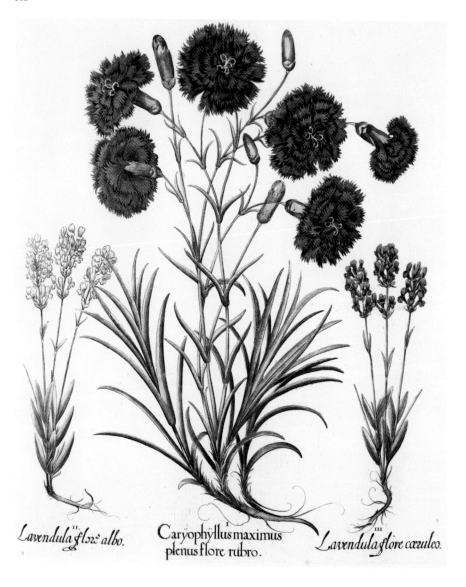

Lavendula flore albo.

Caryophyllus maximus plenus flore rubro.

Lavendula flore cœruleo.

II. LAVANDULA SPEC.
Lavender

I. DIANTHUS CARYOPHYLLUS
Wild carnation

III. LAVANDULA SPEC.
Lavender

PLANTARVM

HORTI EYSTÆT-
TENSIS.

Claffis Autumnalis.

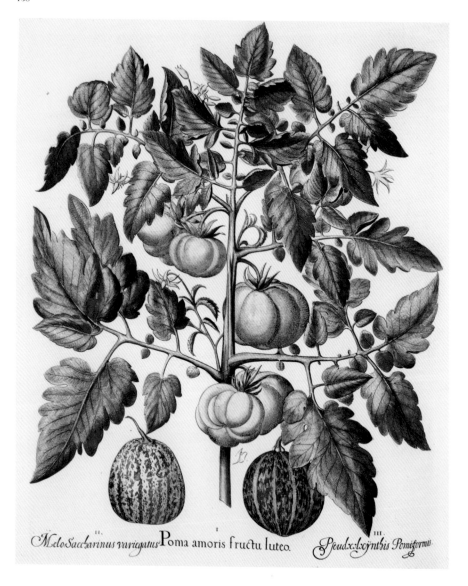

Melo Saccharinus variegatus Poma amoris fructu luteo. Pseudx:lxcynthis Pomiformis

II. CUCUMIS MELO
Melon

I. LYCOPERSICON SPEC.
Tomato
with orange-coloured fruits

III. CITRULLUS LANATUS
Water melon

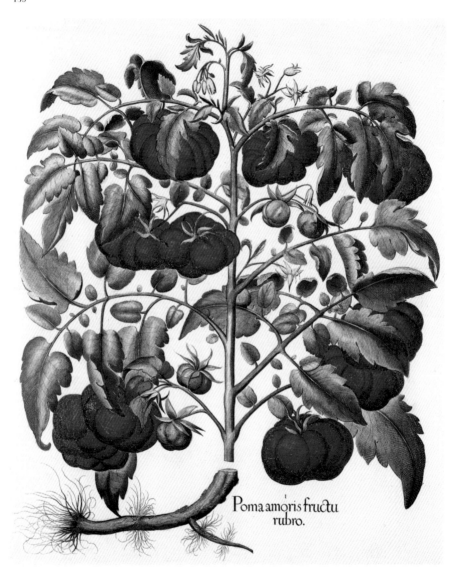

Poma amoris fructu
rubro.

I. LYCOPERSICON ESCULENTUM
Tomato; Love apple

160

Balſamina foemina.

Momordica fructu luteo rubescente.

Balsamina Mas fructu puniceo.

III. MOMORDICA BALSAMINA
Balsam apple

I. IMPATIENS BALSAMINA
Garden balsam; Rose balsam

II. MOMORDICA BALSAMINA
Balsam apple

Piper Indicum medium.

I. CAPSICUM SPEC.
Chilli pepper

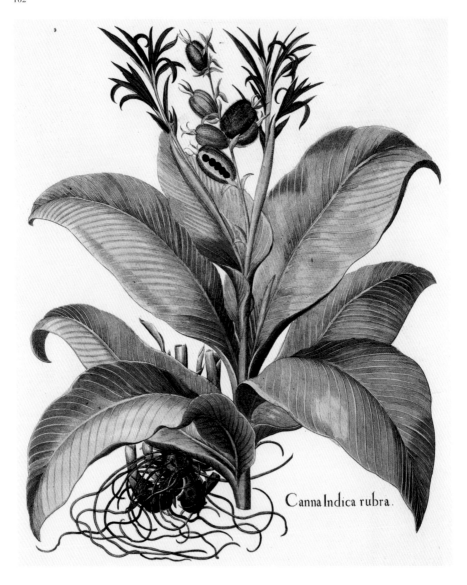

Canna Indica rubra.

1. CANNA INDICA
Red Indian shot

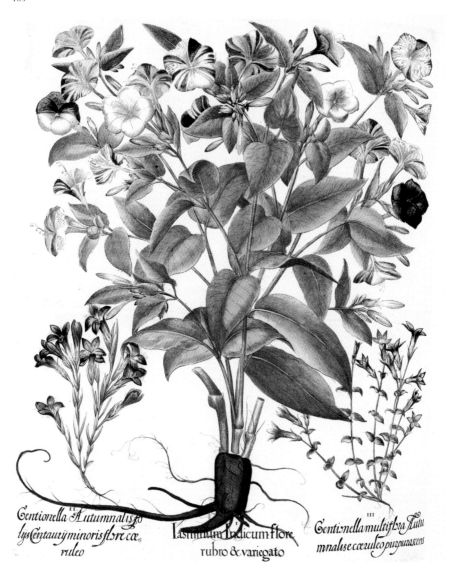

Gentionella Autumnalis sso
lijs Centaurij minoris flore cœ,
ruleo

Iasminum Indicum flore,
rubro & variegato

Gentionella multiflra Jutu
mnalise cœruleo purpurascens

II. GENTIANELLA CILIATA
Fringed gentian

I. MIRABILIS JALAPA
Marvel of Peru;
Four-o'clock flower

III. GENTIANA GERMANICA
Chiltern gentian

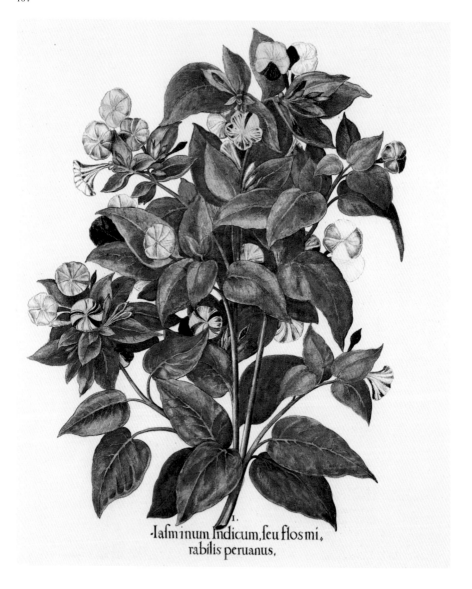

-Iafminum Indicum, feu flos mi,
rabilis peruanus,

I. MIRABILIS JALAPA
Marvel of Peru; Four-o' clock flower

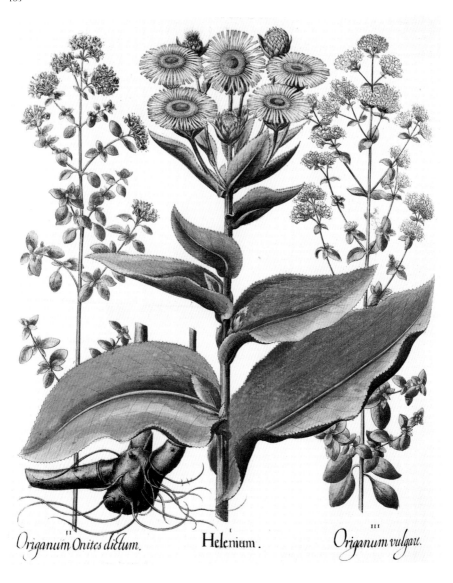

Origanum Onites dictum. • *Helenium.* • *Origanum vulgare.*

II. ORIGANUM VULGARE
Wild marjoram; Oregano

I. INULA HELENIUM
Elecampane

III. ORIGANUM VULGARE
Wild marjoram; Oregano

Amaranthus Tricolor.

I. AMARANTHUS TRICOLOR
Tampala; Chinese spinach

Hieracium minus Hyoseridis latii folia facie

Sesamoides salmanticum parvum

I.
Amarantus maior panniculis
rubris.

II. CREPIS TECTORUM
Hawk's-beard

I. AMARANTHUS PANICULATUS
*Purple amaranth; Red amaranth;
Prince's feather*

III. SILENE OTITES
Spanish catchfly

I.
Stramonia.

III.
Botris Dracontiæmaior.

II.
Halimus.

III. ARUM MACULATUM
Lords-and-ladies; Cuckoo pint;
Jack-in-the-pulpit

I. DATURA METEL
Horn of plenty;
Downy thorn apple

II. HALIMIONE
PORTULACOIDES
Sea purslane

Sorgum fructu rubro. *Sorgo fructu albo.*

I. SORGHUM BICOLOR
Sorghum; Great millet; Kafir corn

II. SORGHUM BICOLOR
Sorghum; Great millet; Kafir corn

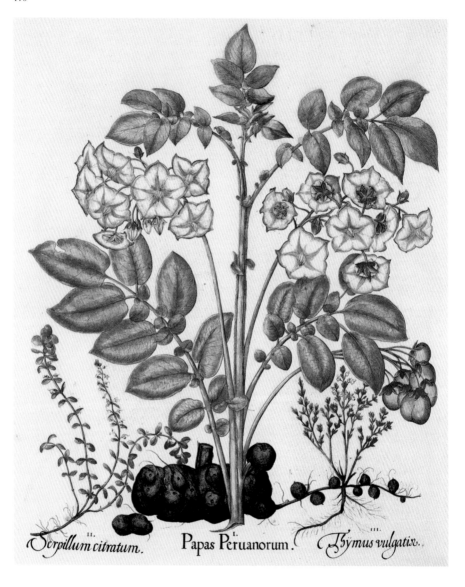

Serpillum citratum. **Papas Peruanorum.** *Thymus vulgatis.*

II. THYMUS PULEGIOIDES I. SOLANUM TUBEROSUM III. THYMUS VULGARIS
Broad-leaved thyme; Large thyme *Potato* *Common thyme*

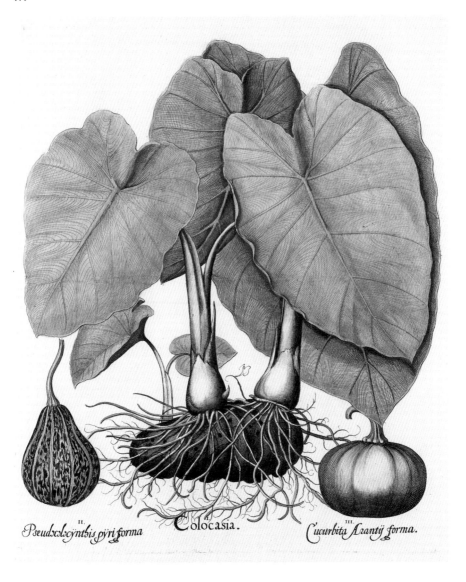

II.
Pseudocolocynthis pyri forma

I.
Colocasia.

III.
Cucurbita Arantij forma.

II. LAGENARIA SPEC.
White-flowered gourd;
Calabash gourd;
Bottle gourd

I. COLOCASIA ESCULENTA
Cocoyam; Taro; Dasheen

III. CUCURBITA PEPO
Pumpkin; Squash; Marrow;
Courgette; Zucchini

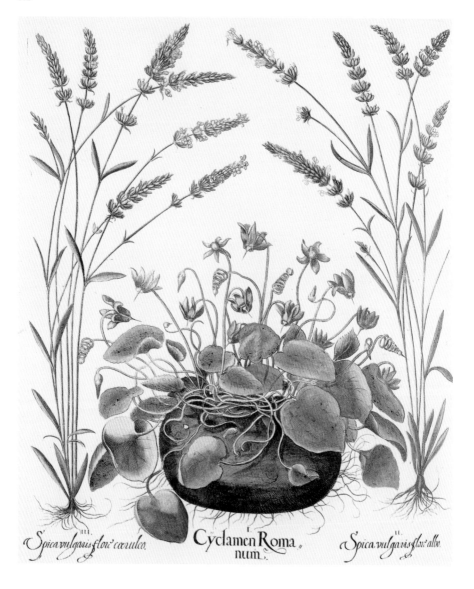

Spica vulgaris flore cæruleo. *Cyclamen Roma-* *Spica vulgaris flore albo.*
 num.

III. LAVANDULA LATIFOLIA I. CYCLAMEN HEDERIFOLIUM II. LAVANDULA LATIFOLIA
Spike lavender *Sowbread* *Spike lavender*

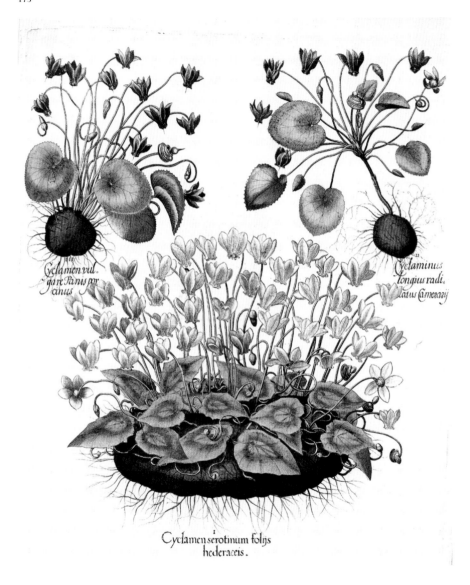

Cyclamen vul
gare Panis por
cinus

Cyclaminus
longius radi.
latus Camerarij

Cyclamen serotinum folijs
hederaceis.

III. CYCLAMEN PURPURASCENS
Sowbread

I. CYCLAMEN HEDERIFOLIUM
Sowbread

II. CYCLAMEN PURPURASCENS
Sowbread

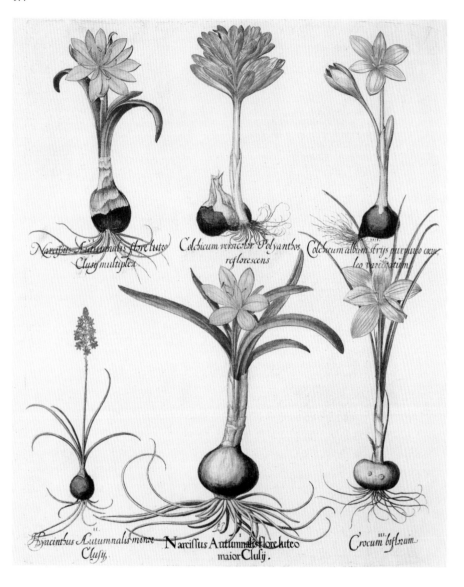

Narcissus Autumnalis flore luteo
Clusy multiplex

Colchicum versicolor Polyanthos
reflorescens

Colchicum album strijs purpureo coeru
leo varicgatum

Hyacinthus Autumnalis minor
Clusy.

Narcissus Autumnalis flore luteo
maior Clusij.

Crocum bislrum

VI. STERNBERGIA LUTEA
Autumn daffodil

V. COLCHICUM AUTUMNALE
Double meadow saffron

IIII. COLCHICUM AUTUMNALE
Meadow saffron

II. SCILLA AUTUMNALIS
Autumn squill

I. STERNBERGIA LUTEA
Autumn daffodil

III. CROCUS SATIVUS
Saffron

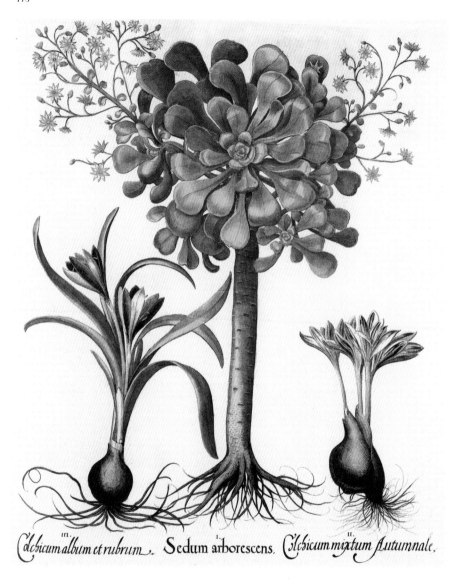

Colchicum album et rubrum. **Sedum arborescens.** *Colchicum mixtum Autumnale.*

III. COLCHICUM SPEC.
Bi-coloured autumn crocus in leaf;
Naked ladies

I. AEONIUM ARBOREUM
Houseleek

II. COLCHICUM SPEC.
Autumn crocus;
Naked ladies with striped leaves

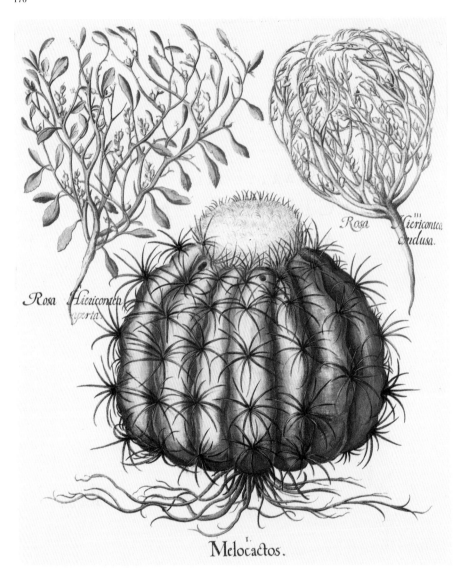

Rosa Hiericontea aperta.

Rosa Hiericontea III conclusa.

I.
Melocactos.

II. ANASTATICA
HIEROCHUNTICA
Rose of Jericho; Resurrection plant

I. MELOCACTUS INTORTUS
Turk's cap cactus

III. ANASTATICA
HIEROCHUNTICA
Rose of Jericho; Resurrection plant

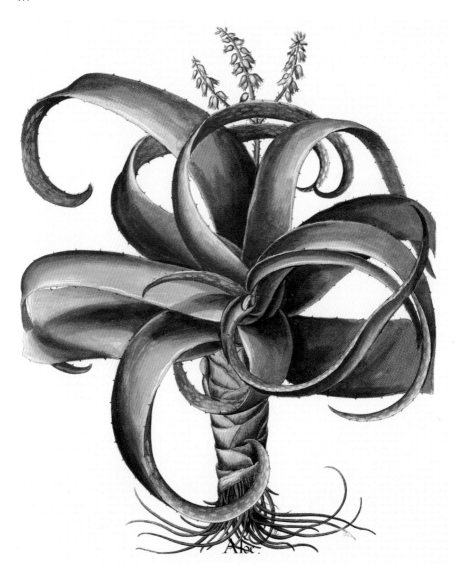

I. ALOË VERA
Barbados aloe; Curaçao aloe

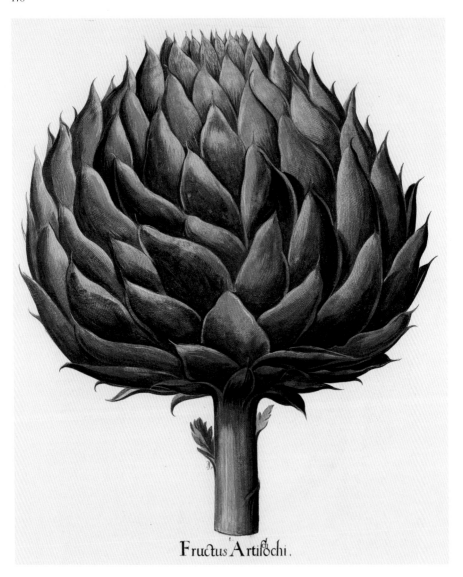

Fructus Artiſochi.

I. CYNARA SCOLYMUS
Globe artichoke

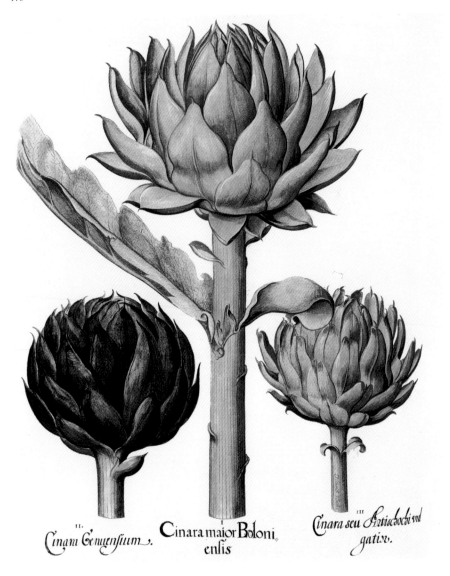

II.
Cinam Genuensium.

I.
Cinara maior Boloni
ensis

III.
Cinara seu Artischochi vul
gatis.

II. CYNARA SCOLYMUS
Globe artichoke

I. CYNARA SCOLYMUS
Globe artichoke

III. CYNARA SCOLYMUS
Globe artichoke

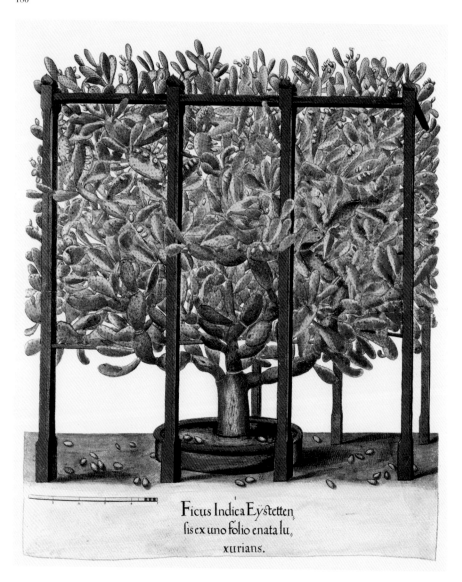

Ficus Indica Eystetten,
sis ex uno folio enata lu,
xurians.

I. OPUNTIA FICUS-INDICA
Indian fig; Prickly pear

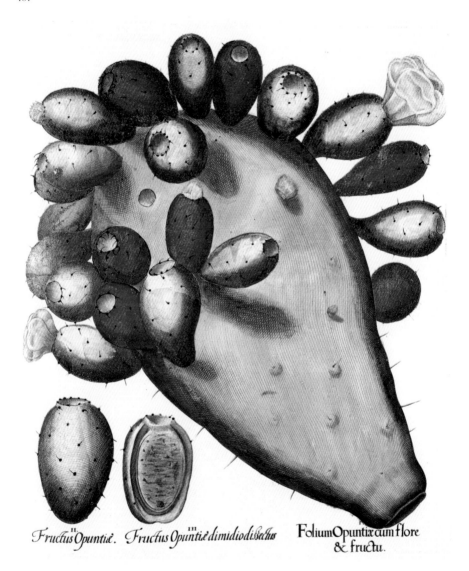

Fructus Opuntiæ. *Fructus Opuntiæ dimidio dissectus* Folium Opuntiæ cum flore
& fructu.

I.-III. OPUNTIA FICUS-INDICA
Indian fig; Prickly pear (stem segment and fruits)

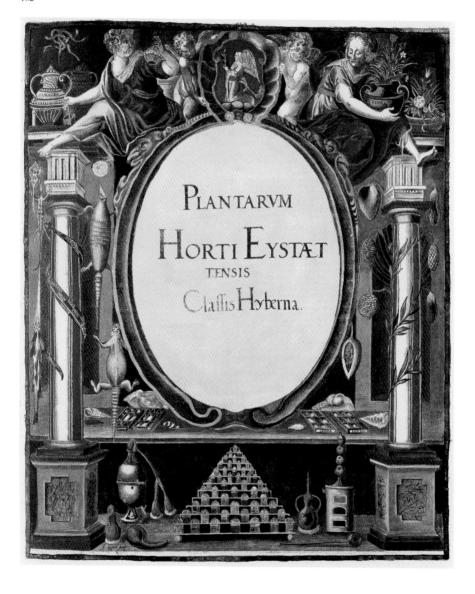

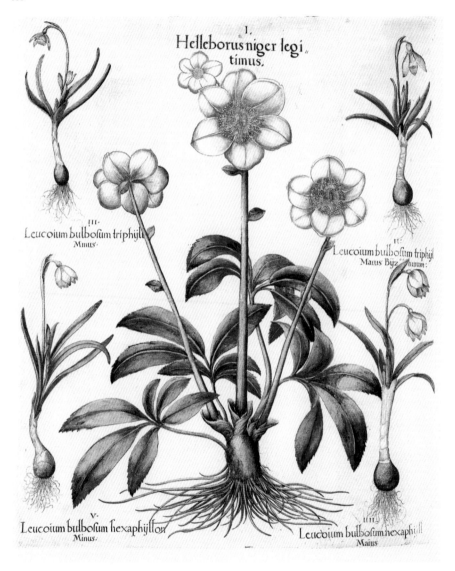

I.
Helleborus niger legi
timus.

III.
Leucoium bulbosum triphyll
Minus.

II.
Leucoium bulbosum triphyl
Maius Byzanthinum.

V.
Leucoium bulbosum hexaphijllon
Minus.

IIII.
Leucoium bulbosum hexaphyll
Maius.

III. GALANTHUS NIVALIS
Snowdrop

I. HELLEBORUS NIGER
Christmas rose

II. GALANTHUS NIVALIS
Snowdrop

V. LEUCOJUM VERNUM
Spring snowflake

IIII. LEUCOJUM VERNUM
Spring snowflake

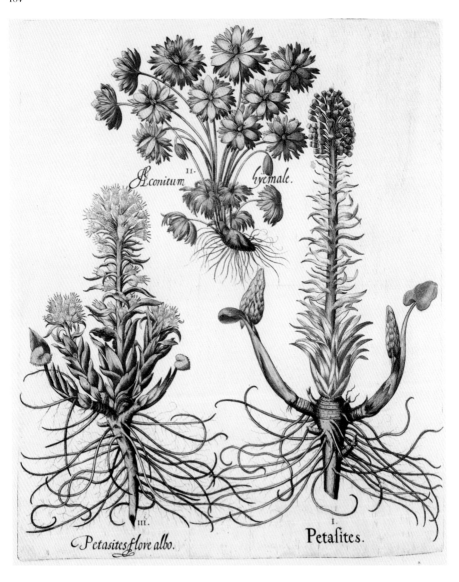

Aconitum II. *hyemale.*

III. *Petasites flore albo.*

I. *Petasites.*

III. PETASITES ALBUS
Butterbur; Sweet coltsfoot

II. ERANTHIS HYEMALIS
Winter aconite

I. PETASITES HYBRIDUS
Bog rhubarb; Common butterbur

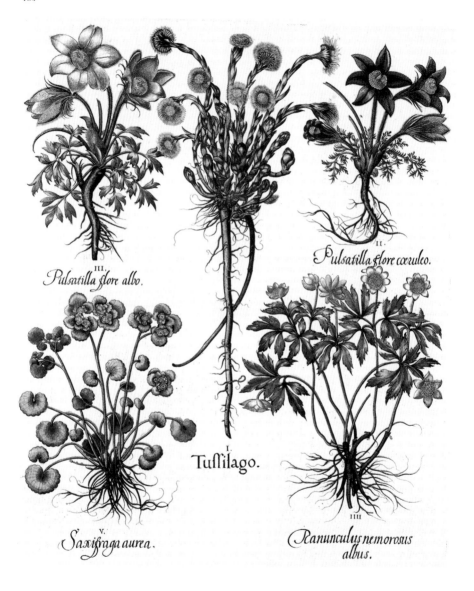

III.
Pulsatilla flore albo.

II.
Pulsatilla flore cœruleo.

I.
Tussilago.

V.
Saxifraga aurea.

IIII.
Ranunculus nemorosus albus.

III. PULSATILLA VERNALIS
Pasque flower

I. TUSSILAGO FARFARA
Coltsfoot

II. PULSATILLA VULGARIS
Pasque flower

V. CHRYSOSPLENIUM
ALTERNIFOLIUM
Golden saxifrage

IIII. ANEMONE NEMOROSA
Windflower; Wood anemone

Index of Modern Botanical and English Plant Names

The hand-coloured copy of the first edition of the *Hortus Eystettensis*, from the Eichstätt University Library (property of the Episcopal College) was used as the model for the printing of the coloured plates. We wish to thank the staff of the library for their kind assistance.

Front and back cover:
TULIPA SPEC.
Tulip with yellow-feathered petals (detail)

© 2001 TASCHEN GmbH
Hohenzollernring 53, D-50672 Köln

www.taschen.com

EDITORIAL COORDINATION
Christiane Blass, Susanne Klinkhamels, Cologne

PRODUCTION
Ute Wachendorf, Cologne

DESIGN
Lambert und Lambert, Düsseldorf

ENGLISH TRANSLATION
Harriet Horsfield in association with
First Edition Translations Ltd., Cambridge, UK

BOTANICAL EDITING
Andrew Mikolajski and Judy Boothroyd in association with
First Edition Translations Ltd., Cambridge, UK

COPYRIGHT
Bernd Ringholz, Ansbach: ILL. 5, 6, 7, 8
Franz Kimmel, Munich: ILL. 4, ILL. pp. 6, 7

ISBN 3-8228-5532-4
Printed in Italy